FOCUS:
REFLECTIONS

Your World, Your Images

LARK

An Imprint of Sterling Publishing Co., Inc.
New York

WWW.LARKCRAFTS.COM

Senior Editor:
Nicole McConville

Image Editor:
Cassie Moore

Editor:
Julie Hale

Art Director & Cover Designer:
Travis Medford

Library of Congress Cataloging-in-Publication Data

Focus : reflections : your world, your images. -- 1st ed.
 p. cm.
 Includes index.
 ISBN 978-1-60059-712-1 (alk. paper)
 1. Photography, Artistic. 2. Reflection (Optics) in art. I. Lark Crafts (Firm) II. Title: Reflections. III. Title: Your world, your images.
 TR655.F624 2011
 779--dc22
 2011001869w

10 9 8 7 6 5 4 3 2 1

First Edition
Published by Lark Crafts, An Imprint of Sterling Publishing Co., Inc.
387 Park Avenue South, New York, NY 10016

Text © 2011, Lark Crafts
Photography © 2011, Artist/Photographer

Distributed in Canada by Sterling Publishing,
c/o Canadian Manda Group, 165 Dufferin Street
Toronto, Ontario, Canada M6K 3H6

Distributed in the United Kingdom by GMC Distribution Services,
Castle Place, 166 High Street, Lewes, East Sussex, England BN7 1XU

Distributed in Australia by Capricorn Link (Australia) Pty Ltd.,
P.O. Box 704, Windsor, NSW 2756 Australia

If you have questions or comments about this book, please contact:
Lark Crafts
67 Broadway
Asheville, NC 28801
828-253-0467

Manufactured in China

ISBN 13: 978-1-60059-712-1

For information about custom editions, special sales, and premium or corporate purchases, please contact Sterling Special Sales Department at 800-805-5489 or specialsales@sterlingpub.com.

For information about desk and examination copies available to college and university professors, requests must be submitted to academic@larkbooks.com. Our complete policy can be found at www.larkcrafts.com.

Page 7
Andy Teo
Squaring the Circles

Contents

fo • cus: a central point of attraction

Your World
When walking down a busy city street or strolling through a wooded park, do you scan your surroundings with hungry eyes? Do you find yourself on a visual safari hunting snapshots of beauty, intrigue, or surprise amid the ordinary fodder of the everyday? All of us, from professionals to beginners, can take engaging and even breathtaking photographs just by observing the world around us. Meaningful images are everywhere, just waiting to be spotted and captured.

Your Images
Visit any number of online image-hosting sites, and you'll quickly realize how eager we are to snap, organize, and share what we see—in the form of millions upon millions of digital images. Technology has not only provided the tools, it has also fostered a vibrant community ready to embrace and encourage our infatuation with the visual image.

The Series
In *Focus: Reflections*, the fifth entry in this series, a passion for the visual appeal of reflections takes center stage. Whether it's a mirror image of a breathtaking landscape captured on the still surface of a lake, an abstract study in color and line distorted by the afternoon sun against the façade of a building, or the photographer himself revealed in the shining sunglasses of his intended subject, reflections are captivating and enticing.

The Focus
What is it about reflections that captures the eye? Perhaps it's their powerful ability to demonstrate that the world is greatly affected by our own perspectives. Things may be more than they seem.

Within these pages you'll find the work of 99 photographers from 28 different countries, along with their comments on their images, details about where they took the photos, and their thoughts on the general theme of reflections. Their images and words range from the artful to the surprising—just like the reflections we encounter every day.

Peruse, and discover the magic before your eyes.

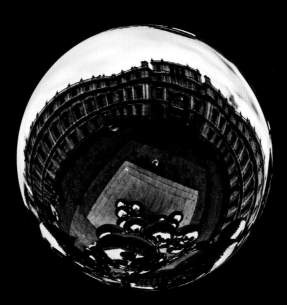

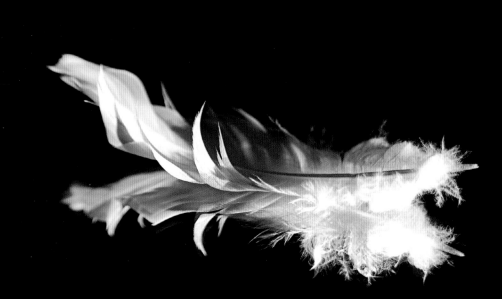

Rhonda Gibson
Softly Touching My Heart
Stilwell, Oklahoma

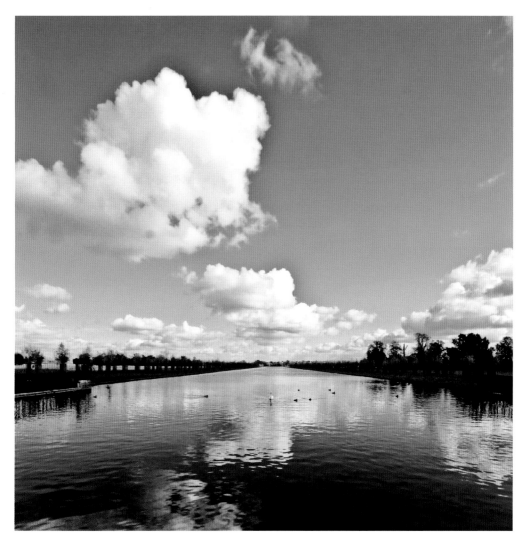

Andy Teo
Classical Blues
Hampton Court Palace, London, England

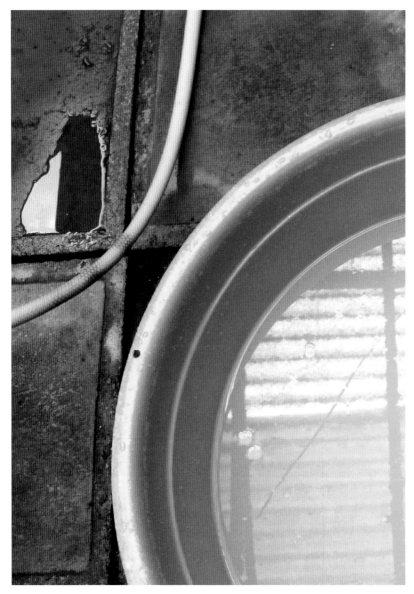

Jo Abaya-Santos
Laundry-Day Reflections
Quezon City, Philippines

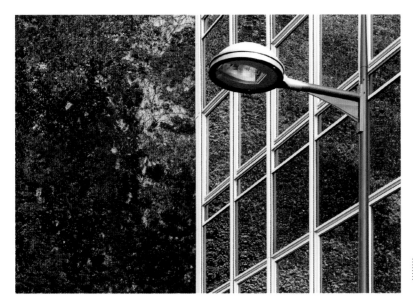

Loïc Kervagoret
Wall of Fire
La Défense, Paris, France

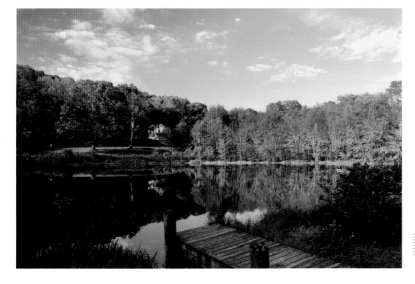

John F. Wenceslao, MD
Sunset Pond
Essex, Connecticut

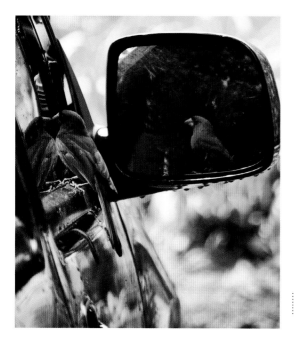

Amy LeJeune
Twitterpated
Laurel Hill, Florida

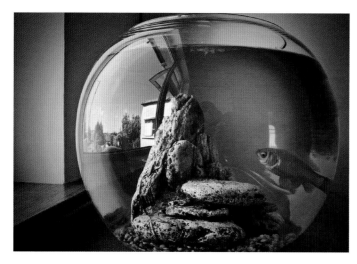

John Mee
Fishbowl
Castlebar, County Mayo, Ireland

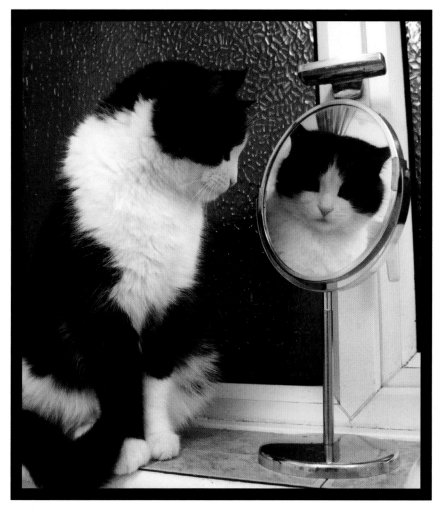

Jodi Linn Coleman
Nightlight
Portland, Oregon

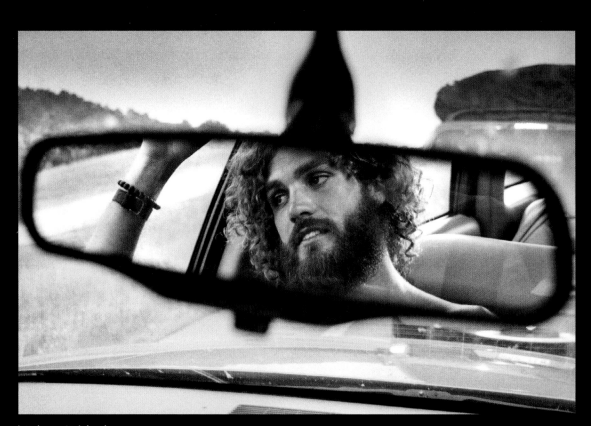

Haley B. Steinhardt
The Waiting
Manchester, Tennessee

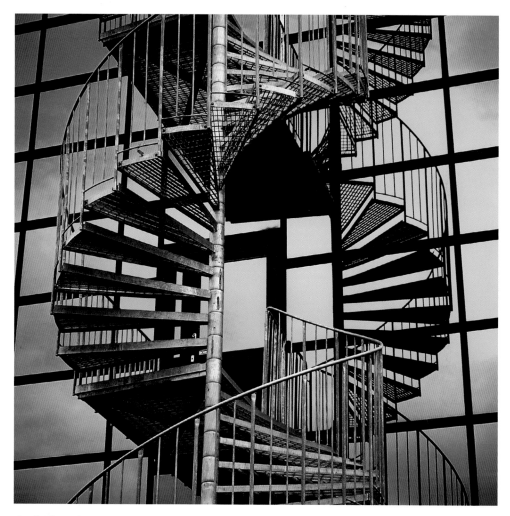

Tomi Tahvanainen
Stairs of Blue
Turku, Finland

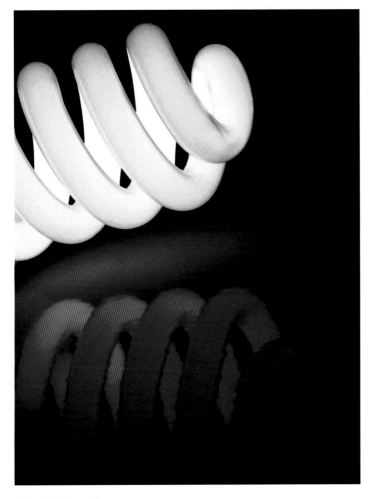

Nawfal Johnson Nur
Twist Bulb Reflection, v.3
Penang, Malaysia

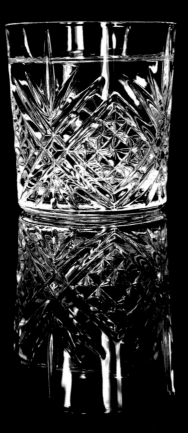

Sudeshna Das
A Glass of Water
Bolingbrook, Illinois

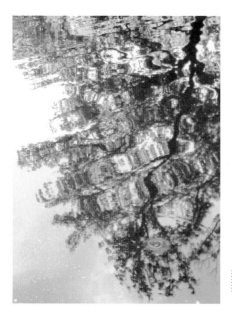

Sara Ames Montague
Reflection II
Ashland, Kentucky

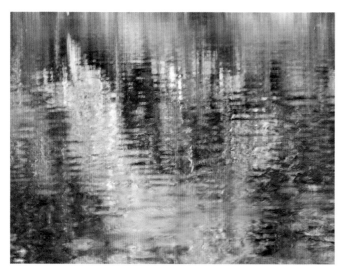

Darrin Hagen
So Green
Wekiva Springs State Park,
Orlando, Florida

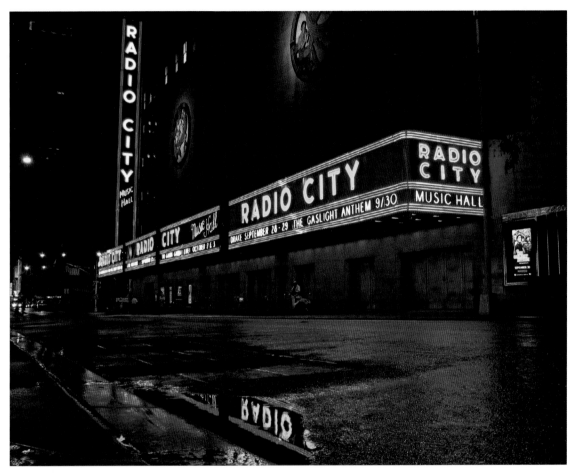

Steven K. Feather
Radio City
New York, New York
The thing I love most about reflections is that you
often get two pictures for the price of one.

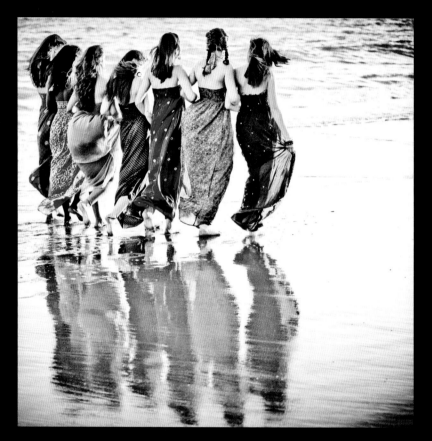

Andy Teo
The Power of Seven
Bournemouth, Hampshire, England

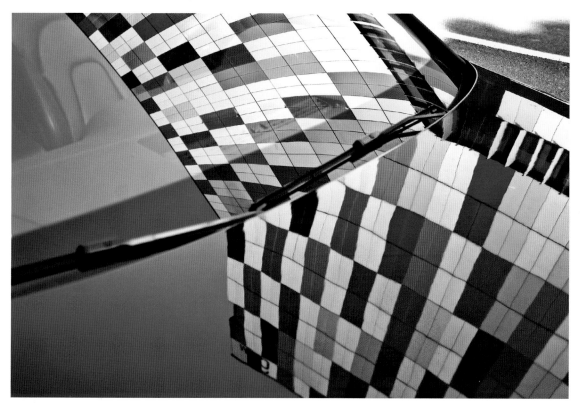

Roberto Faleni
Auto . . . Riflessi
Milan, Italy
Reflections show an overturned world
that duplicates reality.

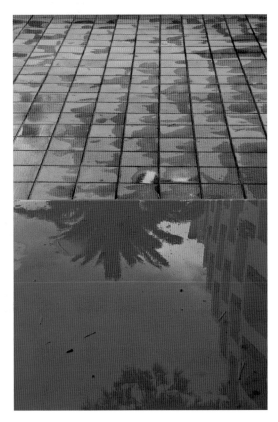

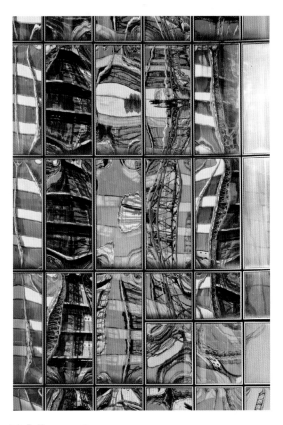

Simone Piccirilli
Riflessi
Menorca, Spain

Loïc Kervagoret
Time Wrap
La Défense, Paris, France
If you study the facades of glass-windowed buildings, you can catch some really impressive distortions and reflections. As I took this picture, I happily discovered that almost every window was telling its own story.

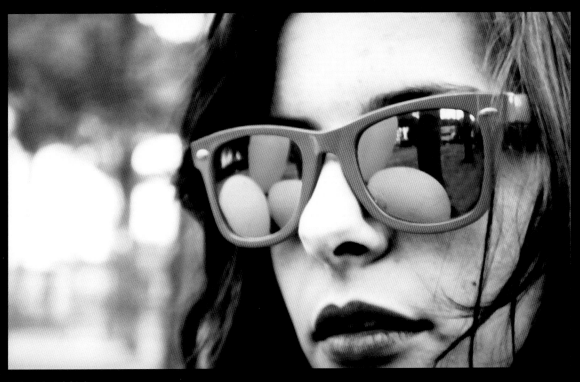

Virginia Falchini
Colors in My Eyes
Livorno, Tuscany, Italy

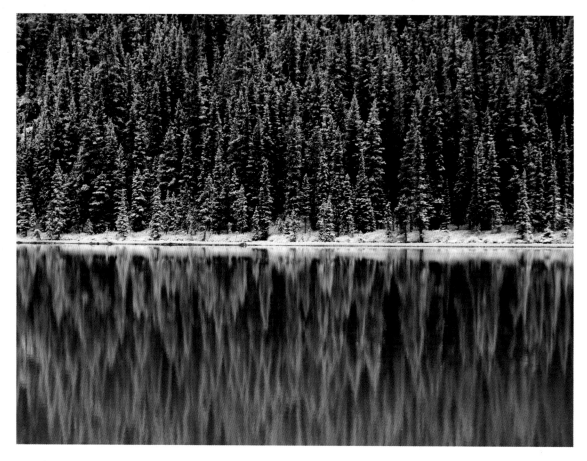

Darrin Hagen
Mirror Pool
Herbert Lake, Banff National Park,
Alberta, Canada

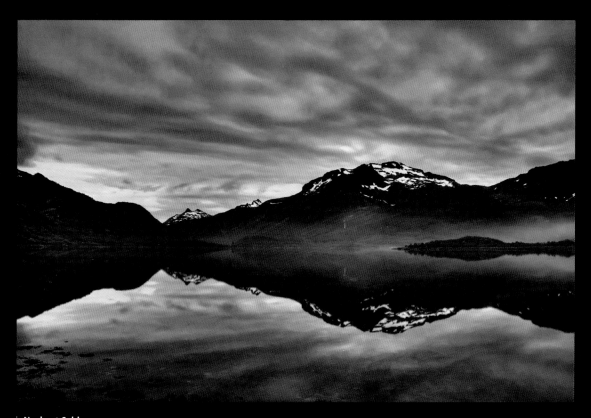

Norbert Schluess
Stunning Nature—Midsummer Night
Lofoten Islands, Norway

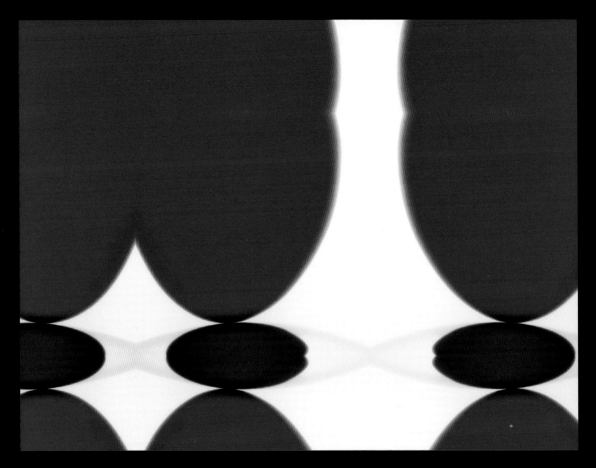

Nawfal Johnson Nur
Egg Reflections, v.1, Edit E
Penang, Malaysia

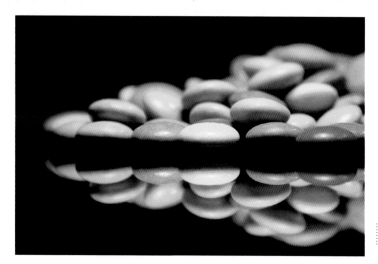

Maurizio Montanaro
Chocolates Fell on a Glass
Turin, Italy

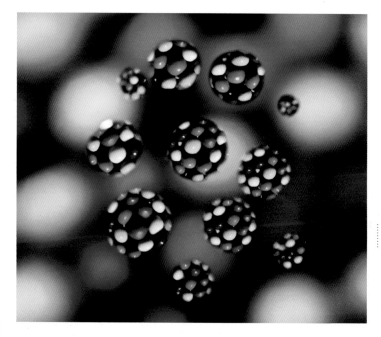

Karl Bernéli
Olive Oil over Bubblegum
Veberöd, Sweden
I like to experiment with reflections and light and try different ideas. I don't want to capture the real world in my photos; I want to manipulate it and trick the viewer's eye—not with an editing program but for real.

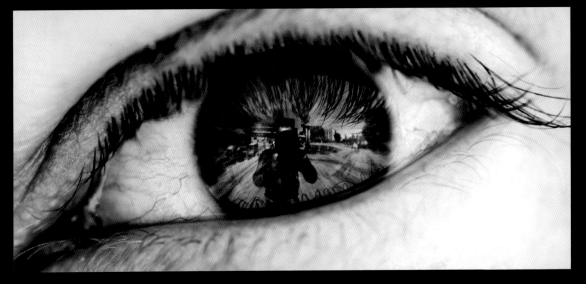

Jan Sveen
lost in space X
Oslo, Norway

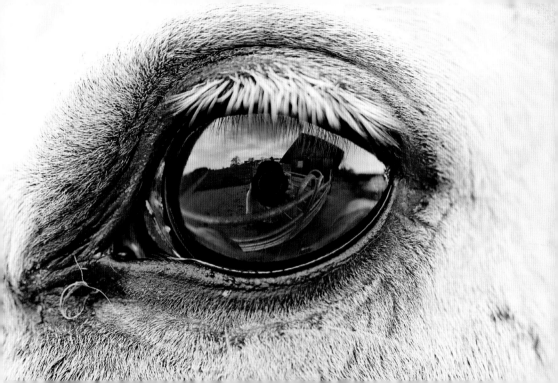

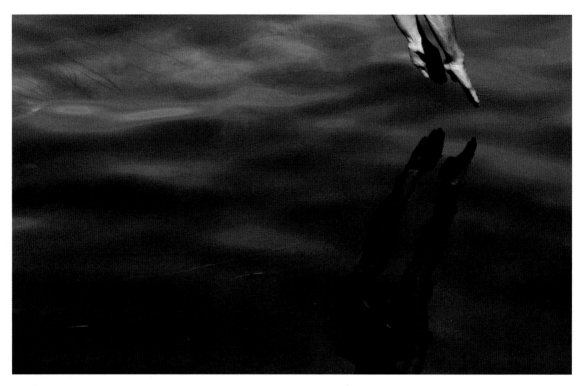

Rune Veslegard
52 mm to Go
Bergen, Norway

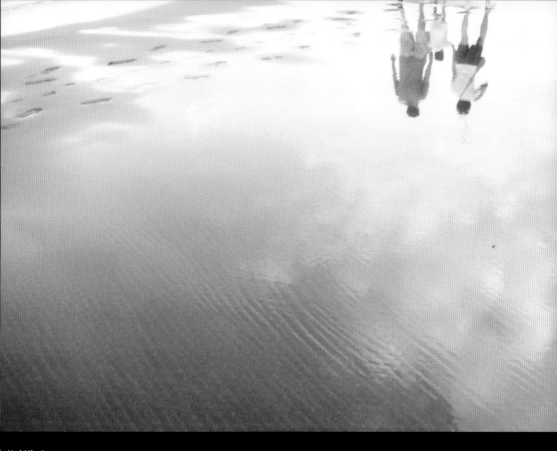

Hui Yin Lu
Fairy Tale
Beach in Toucheng, Taiwan

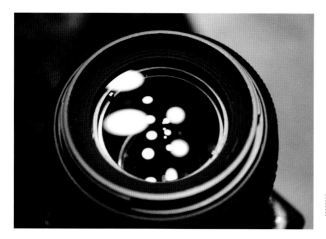

Jonathan Seth Jervan
Reflect Light
Santa Rosa, California

Nicole Cordeiro
Day 1—Reflection
Dallas, Texas

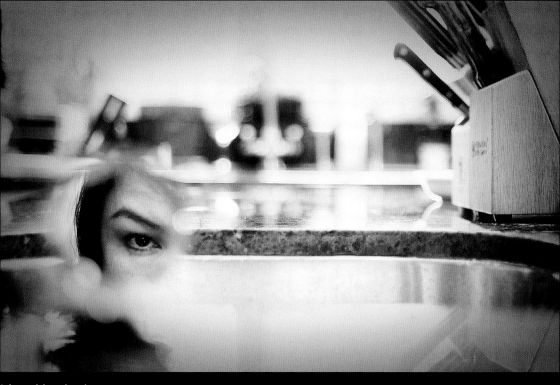

lucyndskywdmnds
Kitchen Nightmares
Palo Alto, California

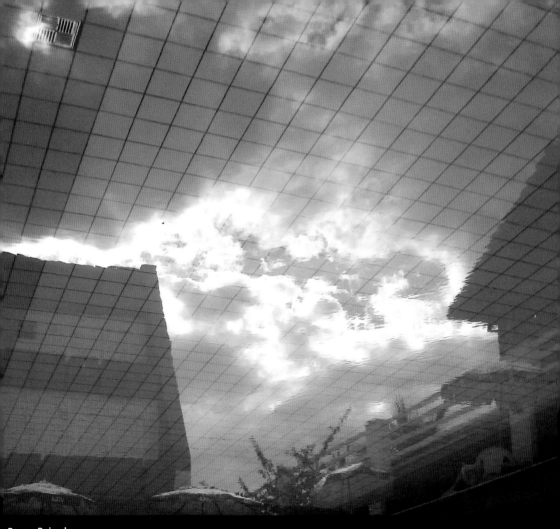

Peggy Reimchen
Monday Blues Confusion
Balneário Eliana Beach, Guaratuba, Brazil

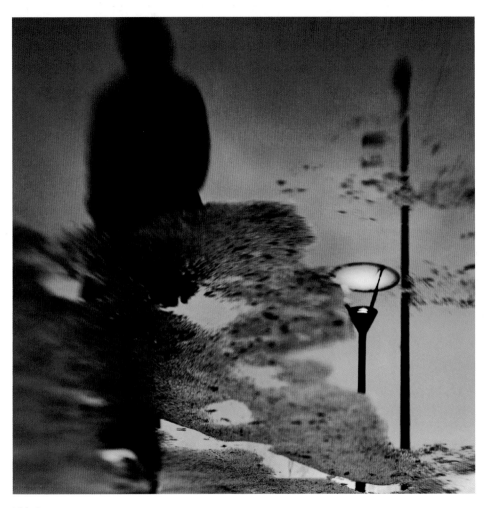

Ida Pap
Gentle Giant
London, England
Reflections are, in a way, abstract
interpretations of reality.

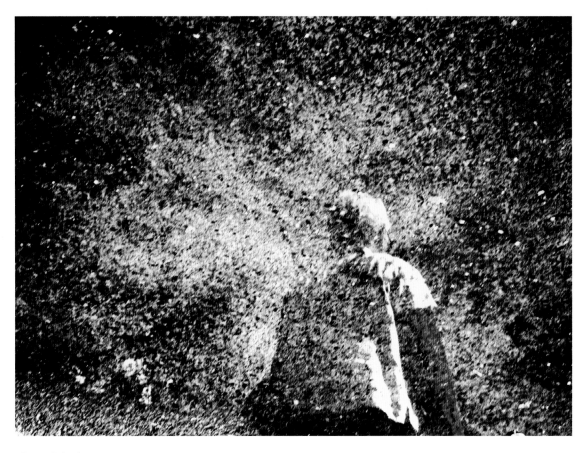

Peggy Reimchen
Water Art: No Rules
Traben-Trarbach, Rhineland-
Palatinate, Germany

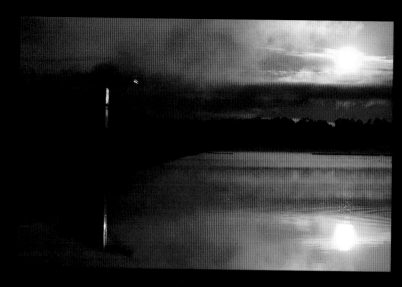

Howard Poon
Reflections at Sunrise
Sydney International Regatta Centre,
Sydney, Australia

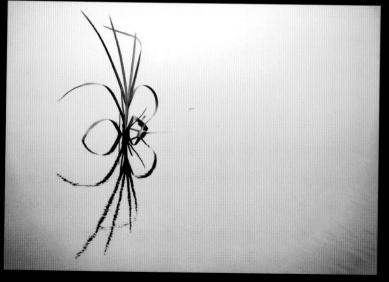

Christa Brouwer
Butterfly Reflections
Krommenie, Netherlands

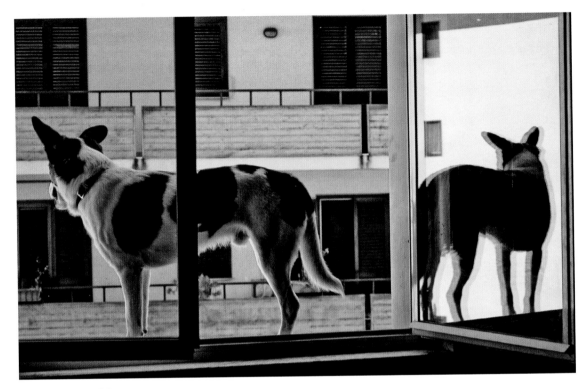

Giovanna Del Bufalo
Per Vedere Meglio
Catania, Italy

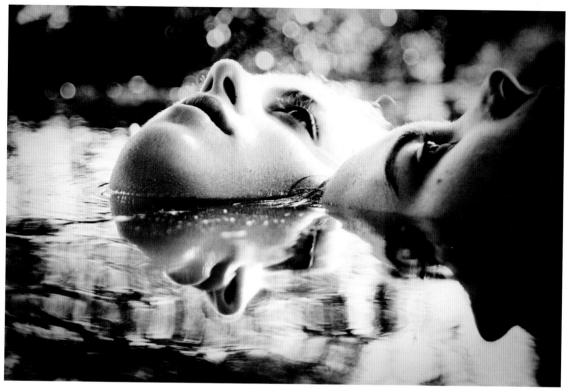

Joey Cardella
Ophelias
Neuquén, Argentina

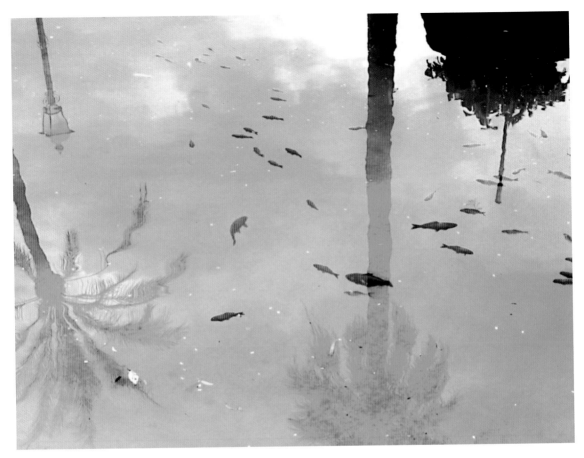

Carmela Privitera
Riflessi
Giardino Ibleo, Ragusa Ibla, Sicily, Italy

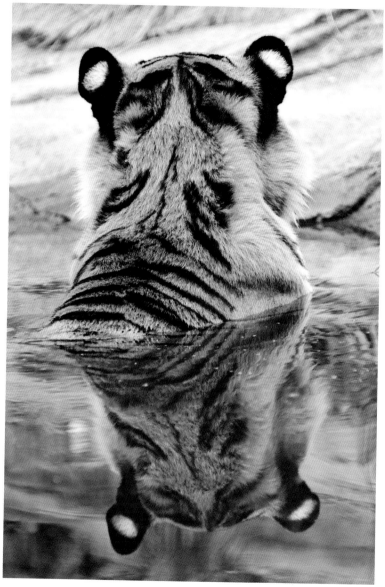

Emmanuel Keller
Tiger Reflection
Zürich, Switzerland

Jodi Linn Coleman
Water Break
Portland, Oregon

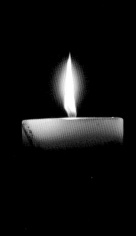

Sudeshna Das
Candle Reflection
Bolingbrook, Illinois

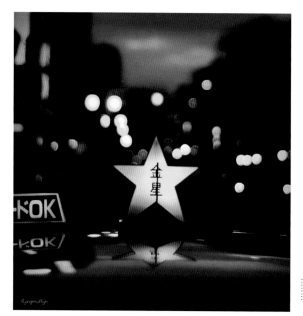

Damien Gan
Sapporo Star
Sapporo City, Hokkaido, Japan

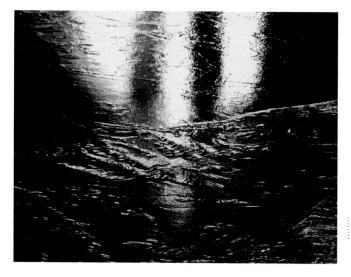

Peggy Reimchen
Reflections: Colorful Layers of Ice
Bluebird Estates, County of Wetaskiwin,
Alberta, Canada

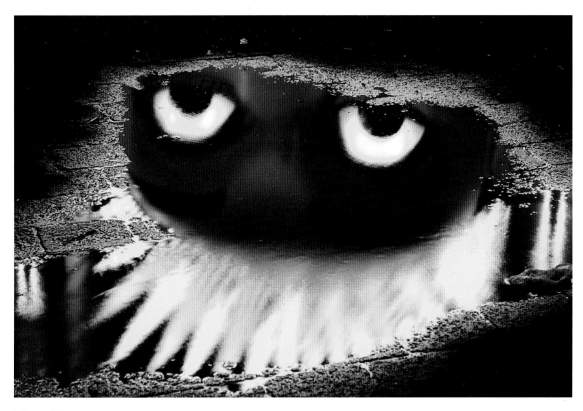

Howard Poon
Reflections of Luna Park
Luna Park, Sydney, Australia

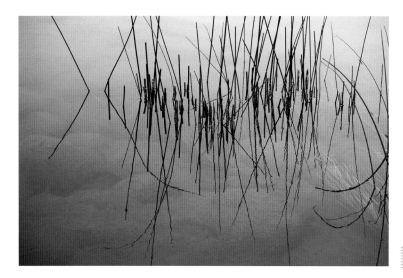

Watana Suthisomboon
Krka, Croatia

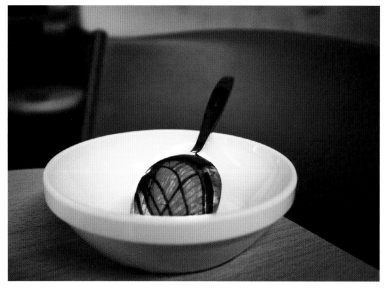

Barry Nagel
Reflection in a Spoon
Bielefeld, Germany

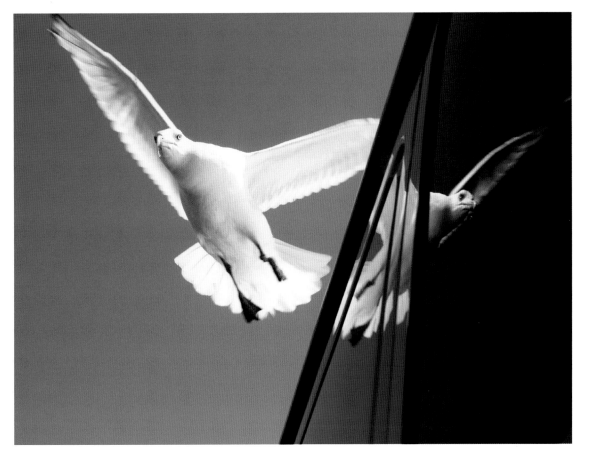

Akke Nynke Jagersma
Spread Your Wings
Netherlands

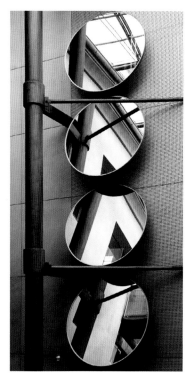

Erwin Vindl
Different Angles
Innsbruck, Tyrol, Austria

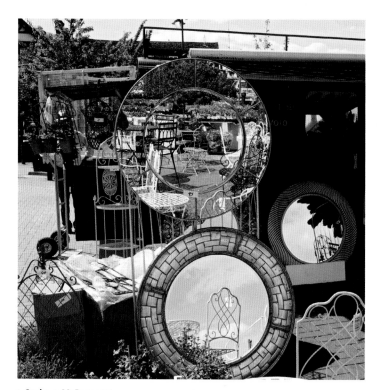

Graham McDermott
The Mirror Stall
Epsom, Surrey, England

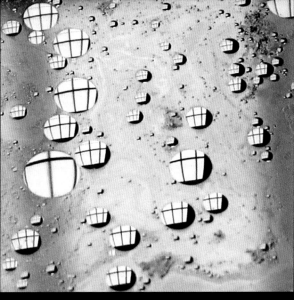

Lida Arzaghi
Bubble
Tehran, Iran

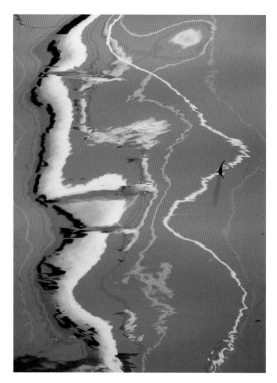

Darrin Hagen
Ripple
Key West, Florida

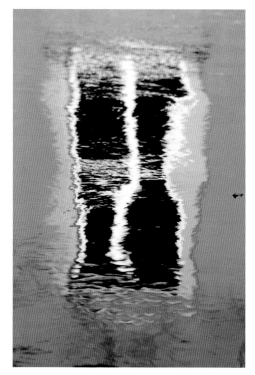

Günter Jörgenshaus
Window in the Water
Burg Wissem, Germany

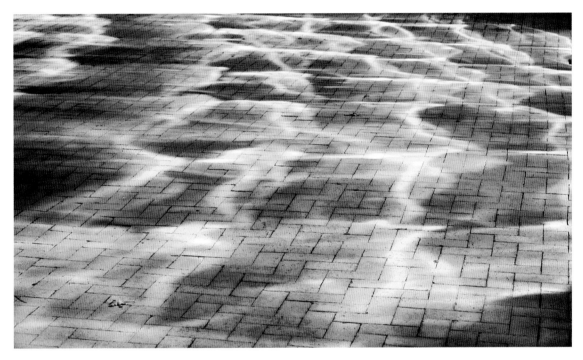

Eugene Zhukovsky
Reflections: Water on Fire
Cambridge, Massachusetts

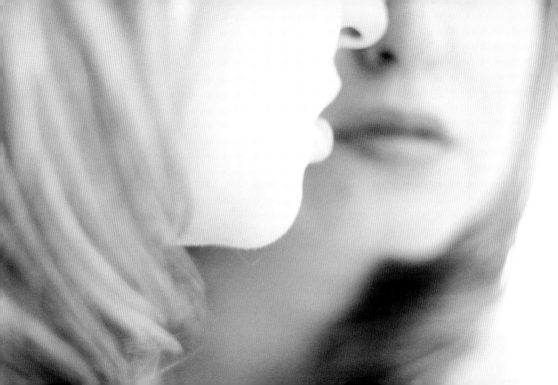

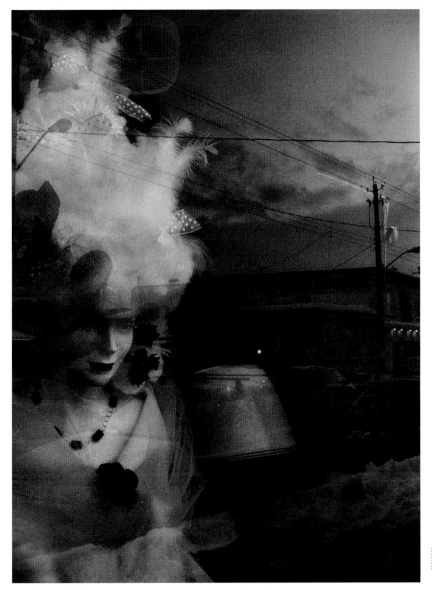

Lee-Anne McMullan
Hintonburg
Ottawa, Canada

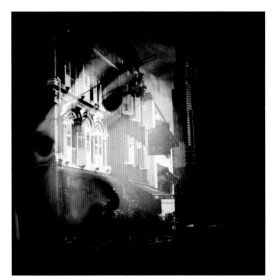

Damien Gan
Face Value
Club Street, Singapore

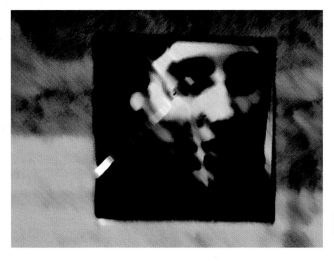

Eduardo da Costa
A Shard in the Broken Mirror
Coburg, Germany

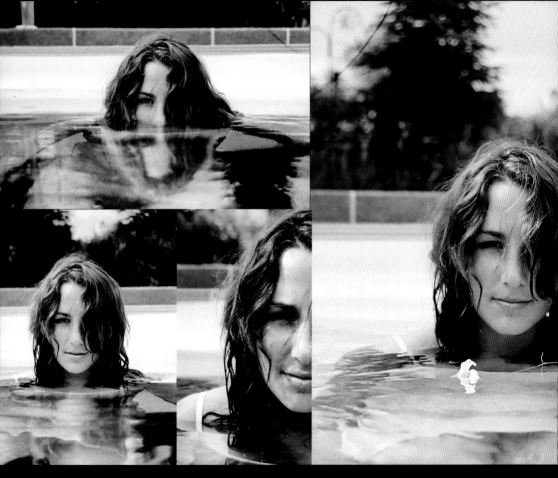

Brian Clancy McGuffog
Submerged
Fishers, Indiana

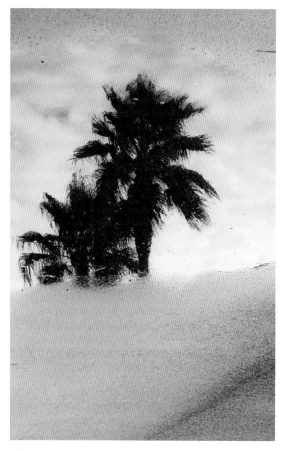

Simone Piccirilli
Miraggio
Menorca, Spain

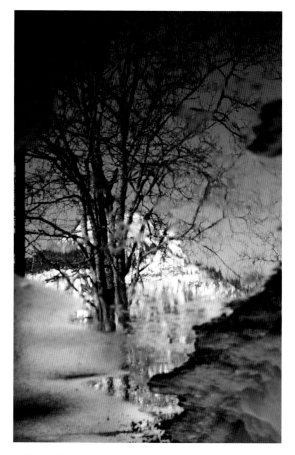

Günter Jörgenshaus
Puddle Reflection
Oberstdorf, Germany

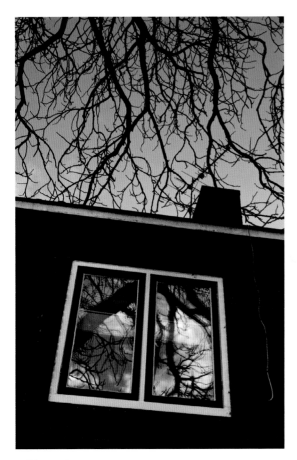

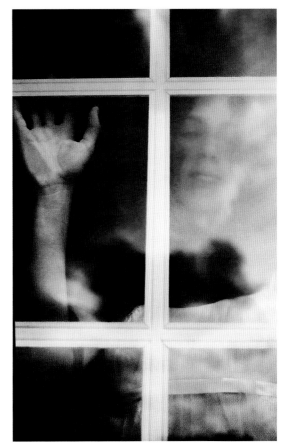

Akke Nynke Jagersma
Haunted House
Twijzelerheide, Netherlands

Brian Clancy McGuffog
Predetermined
Fishers, Indiana

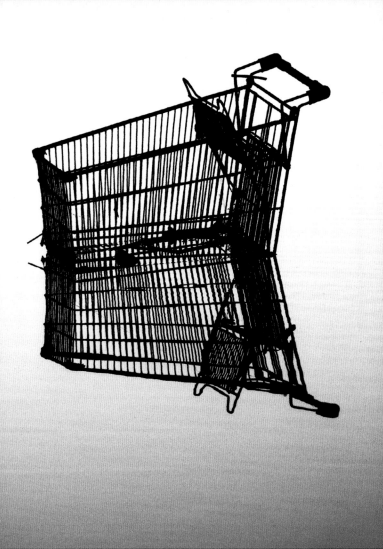

Attila G. Monostori
Abandoned
Brisbane, Australia
I love taking photos of reflections.
The challenging part is finding a
way to capture the image so that
the picture isn't simply a reflection
of an object but also has a wow
factor or some element of a story
or message behind it.

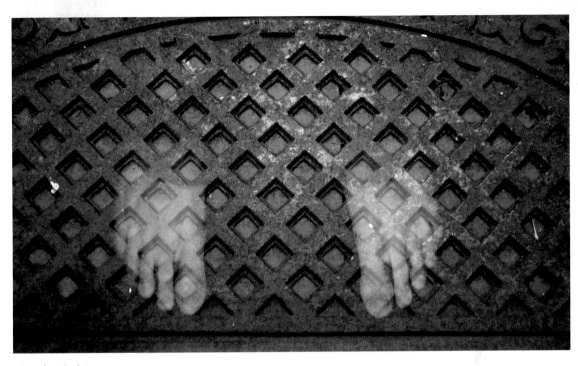

Jonathan Seth Jervan
As if i was there
Santa Rosa, California

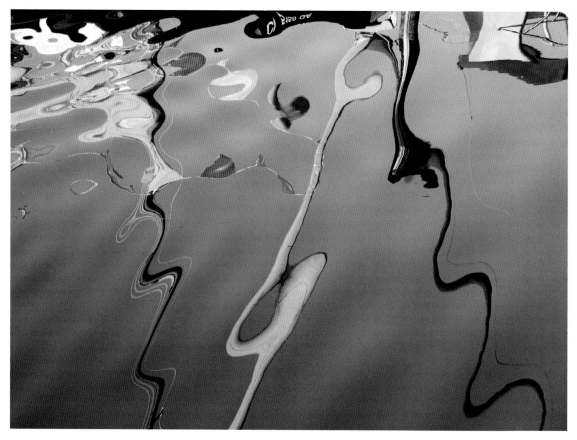

Tomi Tahvanainen
Wall of Light
Turku, Finland

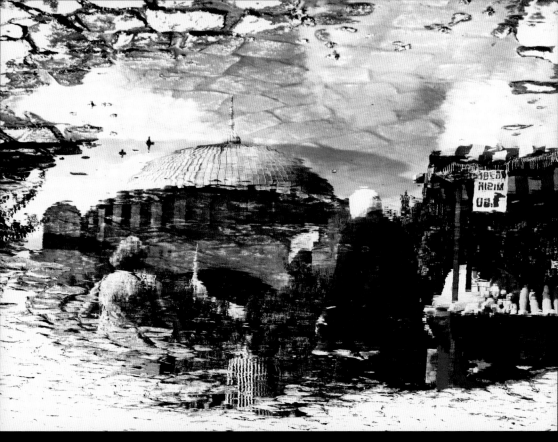

Peggy Reimchen
A Different Way of Seeing Istanbul

Erwin Vindl
Reflection
Innsbruck, Tyrol, Austria

Jutta Voetmann
Note Reflection
Kalkar-Wissel, Germany

Shando Darby
Nothing to Worry About; Just a Little Spill
San Francisco, California

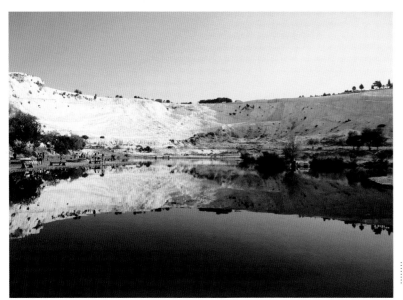

Peggy Reimchen
Double the Pleasure!
Pamukkale, Denizli Province, Turkey

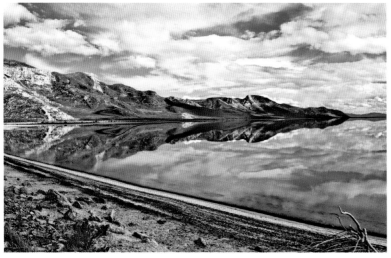

Brad Creze
Edge of the Blade
Stansbury Island, Great Salt Lake, Utah

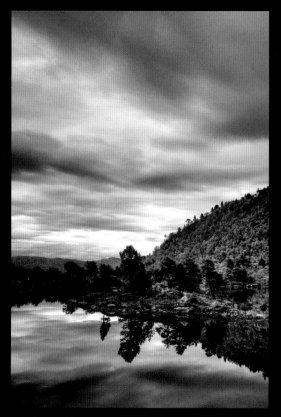

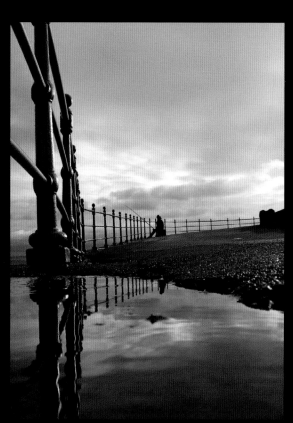

Norbert Schluess
Midsummer Night Reflections
at 1:00 a.m.
Lofoten Islands, Norway

Rosalind Young
Quietly Reflecting
Hartlepool, England

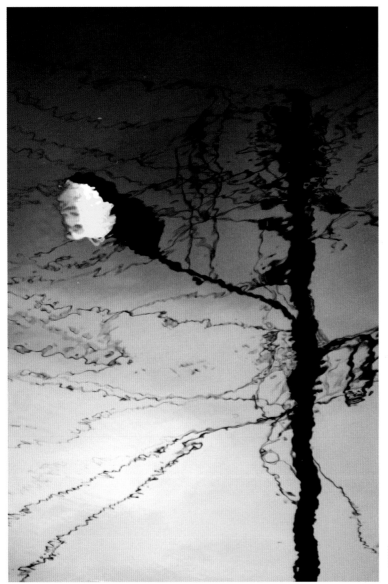

Furhan Hussain
Hope in Gray
Karachi, Pakistan

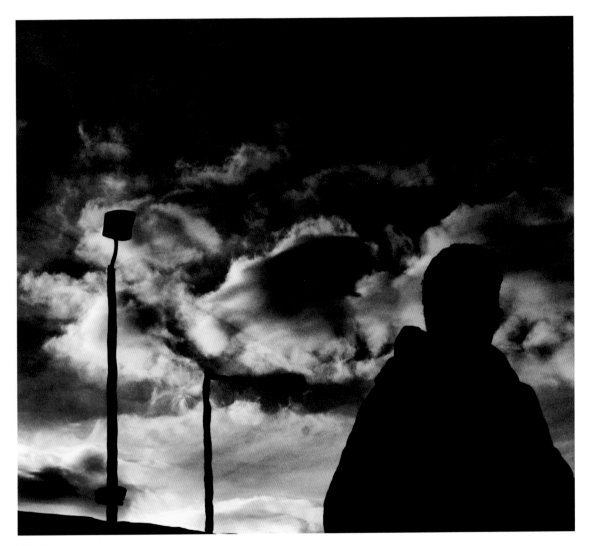

Ida Pap
Stranger
London, England

Adrian Maltby
Green Reflection
Little Thetford, Cambridgeshire, England

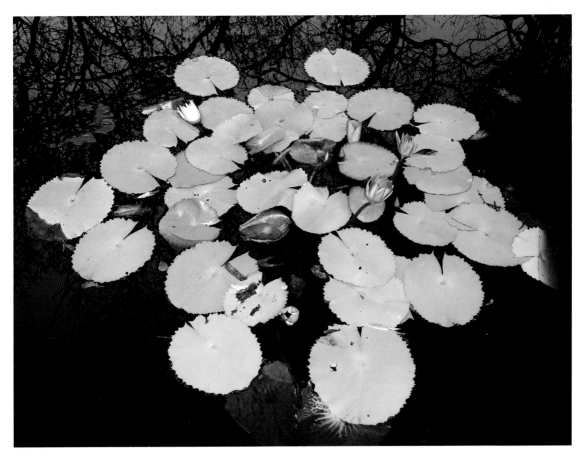

Sara Ames Montague
Lily Pads I
Birmingham, Alabama

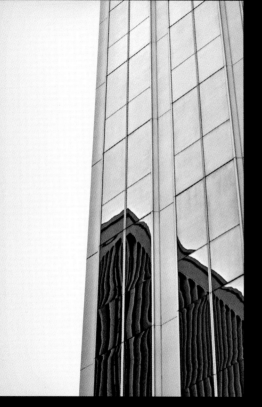

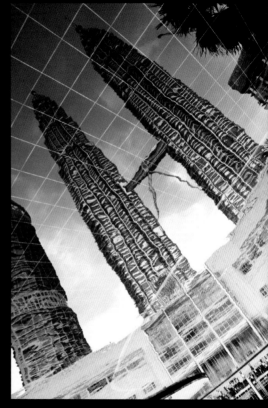

Jodi Linn Coleman
Reflective Lloyd
Portland, Oregon

Edwin Louis G. Arcilla
Malaysian Twins
Kuala Lumpur, Malaysia

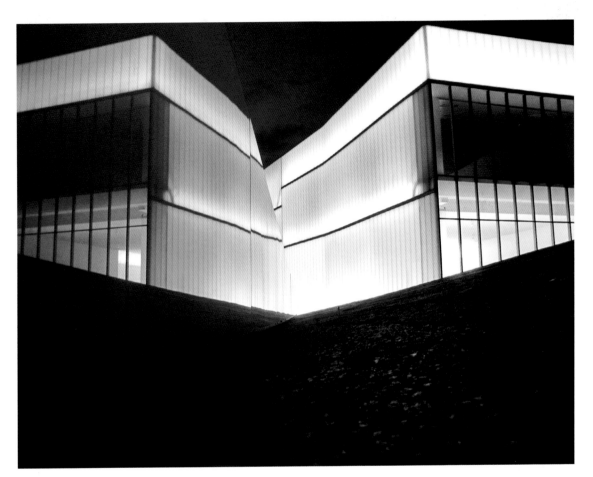

Jeremy Walter
White Wings
Kansas City, Missouri

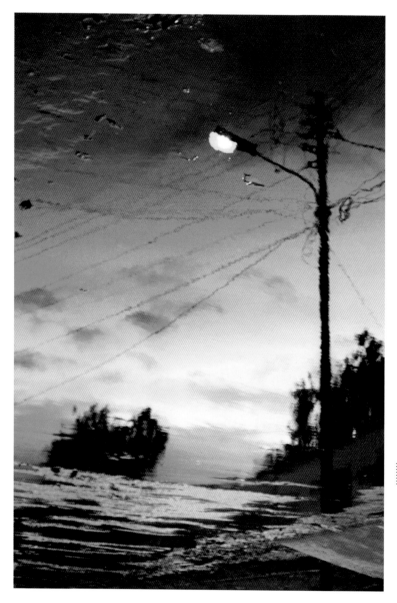

Furhan Hussain
Unveiling
Karachi, Pakistan
The human mind has a way of recalling things in a biased manner—a manner that represents its unique perception of the world. Natural reflections, in many ways, represent nature's biased perspective of reality. It's always challenging to capture that outlook.

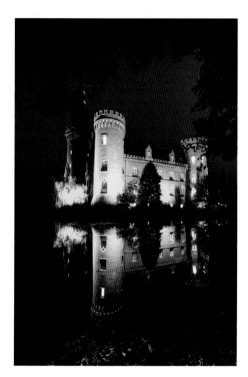

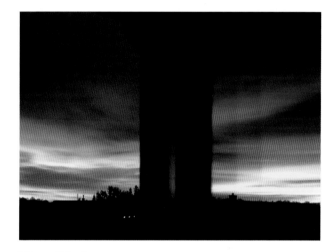

Norbert Schluess
Moyland Castle at Night
Bedburg-Hau, Germany

Peggy Reimchen
I Flung Open My Window to Greet the New Day Dawning
Bluebird Estates, County of Wetaskiwin, Alberta, Canada

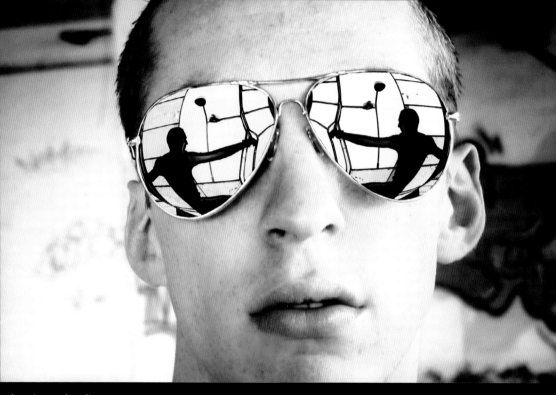

Floortje van der Vlist
The Jump
Abandoned factory in Zaandam, Netherlands
Reflections give us another view of reality.

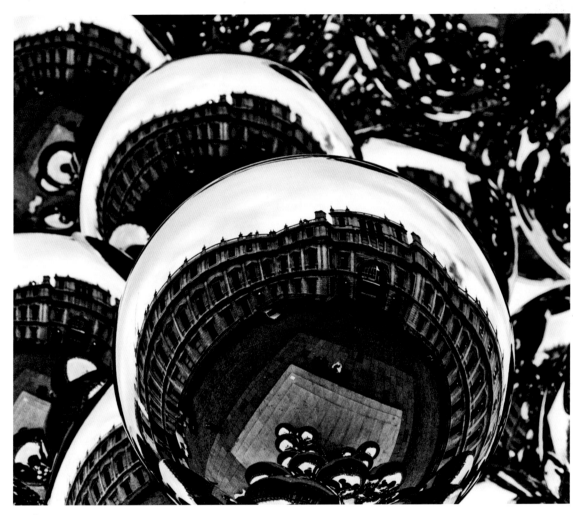

Andy Teo
Squaring the Circles
London, England
I took this photo at the Royal Academy of Arts in London. The
metal spheres are part of an enormous sculpture by artist Anish
Kapoor. If you look very hard, you can see me!

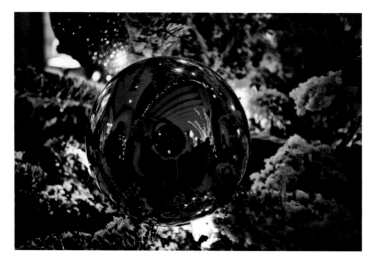

Nicole Cordeiro
Merry Christmas
New Orleans, Louisiana

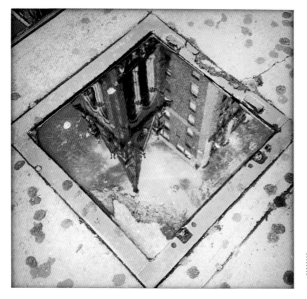

Gerard Garcia
Portal to the Heavens
New York, New York

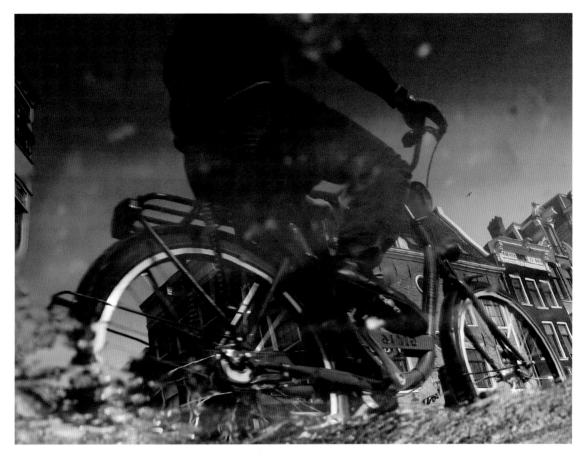

AmsterSam
The Red Rider
Amsterdam, Netherlands
Reflections are a wicked way of opening up a world that's invisible to
most people, even though they walk through it every day.

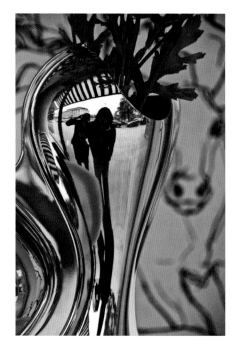

Janne Hytti
Anni Savolainen
Bubbles in the sky
Nurmes, Finland

Janne Hytti
Anni Savolainen
Window Shopping
Savonlinna, Finland

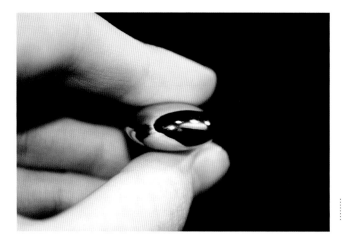

Jonathan Seth Jervan
See My World
Santa Rosa, California

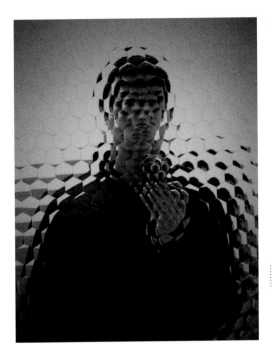

Dominic Carlo Toselli
Eerie Reflections
New York, New York,
I'm intrigued by the sense of abstraction that reflections can bring to a photograph. Reflections disorient viewers, thereby compelling them to make sense of what they're seeing.

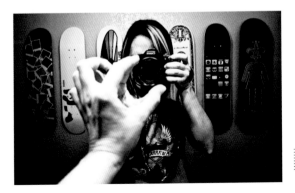

Nicole Cordeiro
Need a Little Adjustment
Dallas, Texas

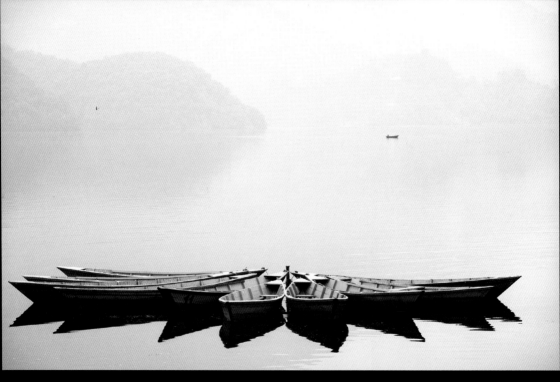

Watana Suthisomboon
Pokhara, Nepal

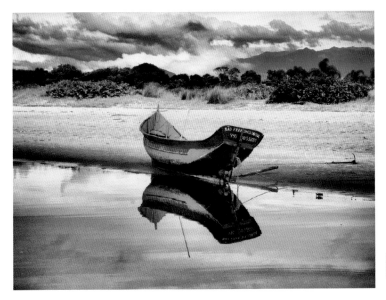

Peggy Reimchen
When One Is Not Enough
Barra do Saí, Paraná, Brazil

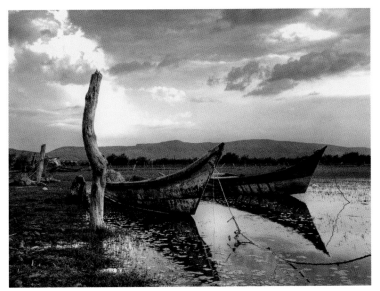

Leonardo Diaz
A Long Journey
Tizapan el Alto, Jalisco, Mexico

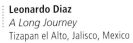

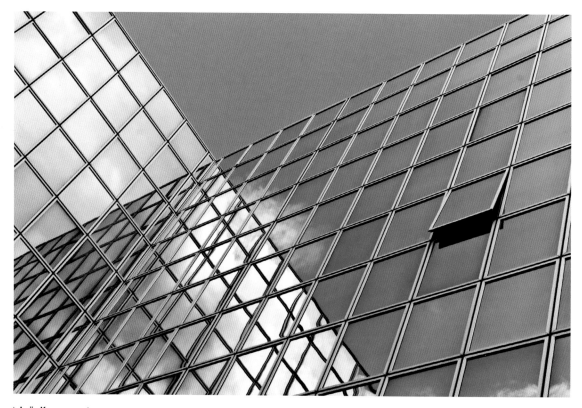

Loïc Kervagoret
Breaking the Mirror
La Défense, Paris, France

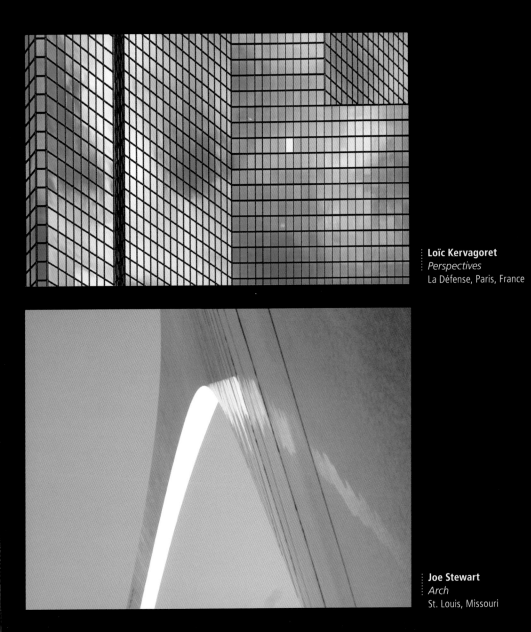

Loïc Kervagoret
Perspectives
La Défense, Paris, France

Joe Stewart
Arch
St. Louis, Missouri

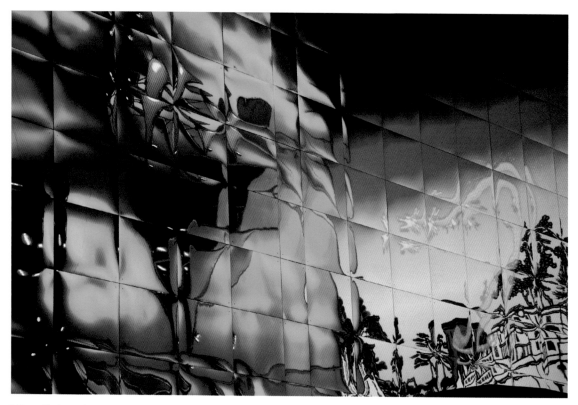

Rune Veslegard
Distorted Future
Shanghai, China

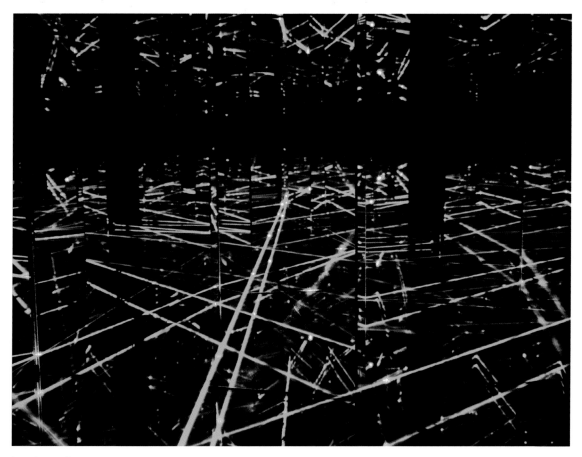

Karl Bernéli
Laser in Mirror Hexagon
Veberöd, Sweden

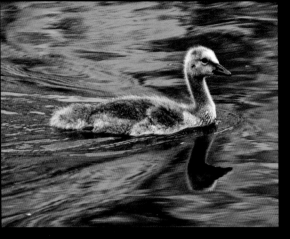

Jan Crites
Out for a Swim
Geneva, Illinois

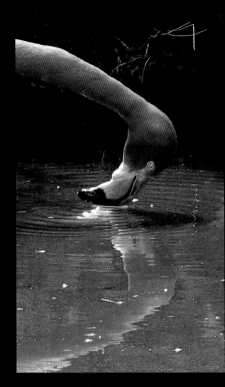

Steven K. Feather
Thirsty

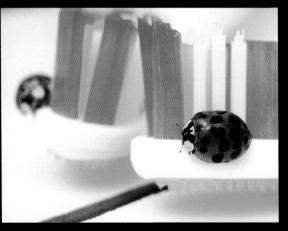

Jan Crites
Ladybug Hygiene
Hiawatha, Iowa

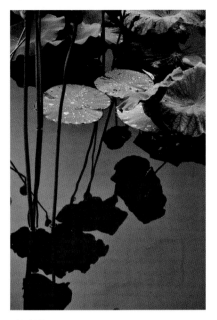

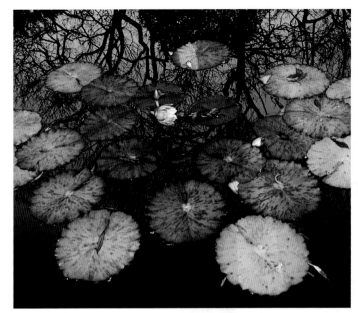

Hui Yin Lu
Lotus in Another Side
Botanical Garden, Taipei, Taiwan

Sara Ames Montague
Lily Pads II
Birmingham, Alabama

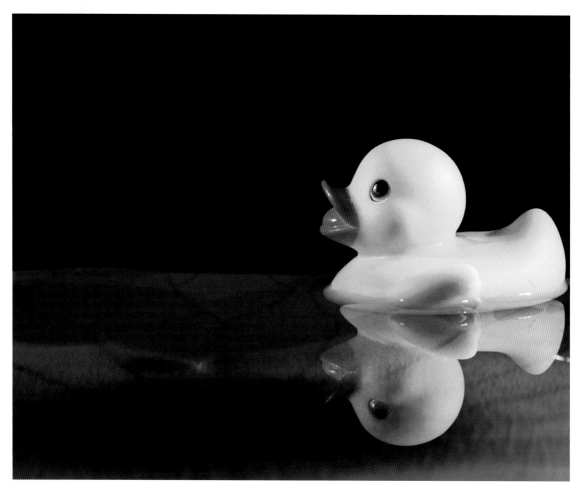

Lynsey S. Ward
Double Duck
Exmouth, Devon, England

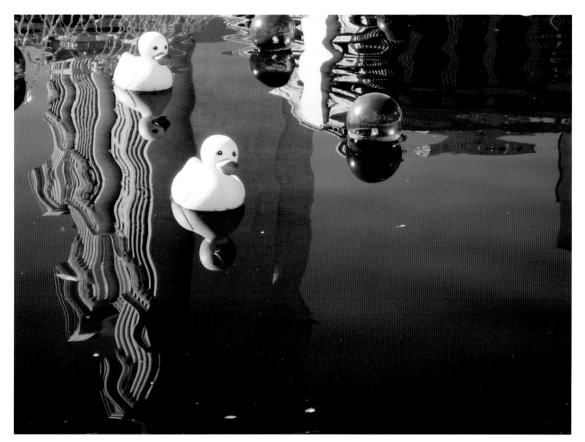

B. Kim Barnes
Las Vegas Wildlife
Las Vegas, Nevada

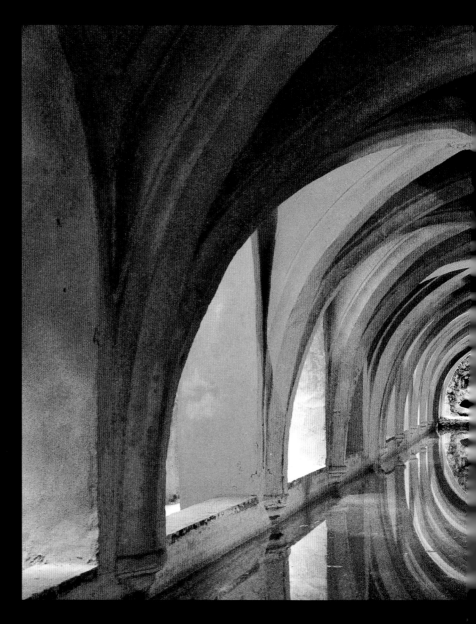

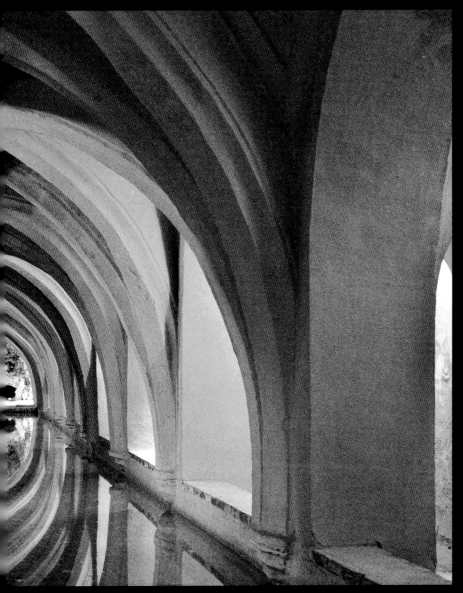

Paolo Miscia
Arcos II
Seville, Spain
Reflections demonstrate that
reality can be an illusion.

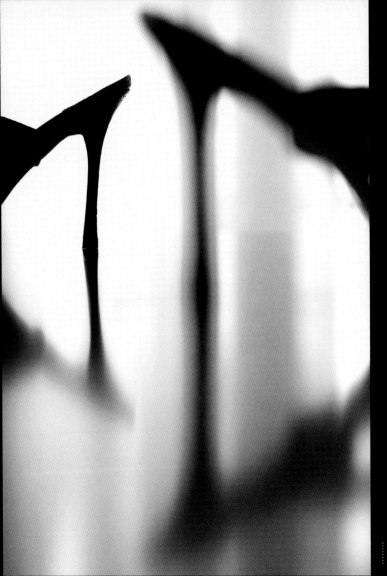

lucyndskywdmnds
Towering Inferno
Palo Alto, California

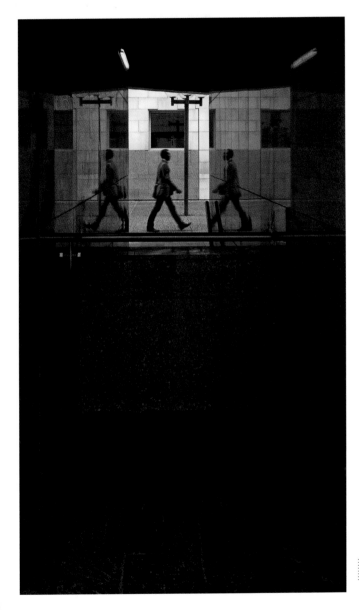

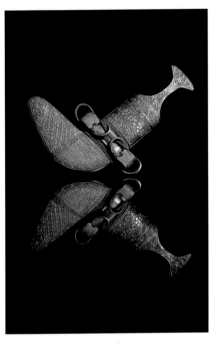

Sudeshna Das
Arabian Dagger Reflection
Bolingbrook, Illinois

Loïc Kervagoret
Triple Personality
La Défense, Paris, France

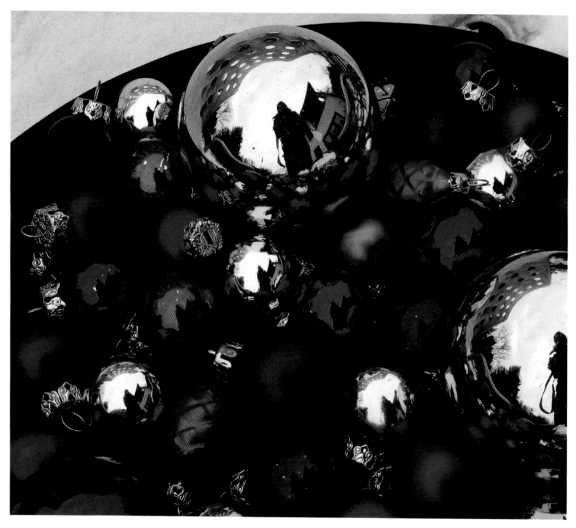

Milena Oehy
Self-Portrait Reflective in Christmas Bauble I
Frauenfeld, Switzerland

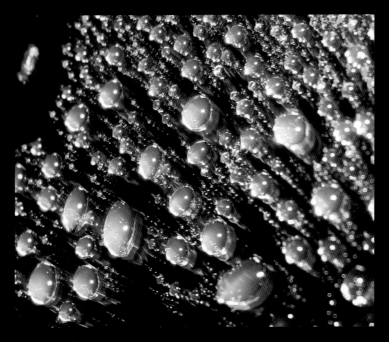

Osvaldo Eaf
Jellyfish Rising
Goiânia, Brazil
This shot came about while I was playing with droplets of water on a CD surface—one of the coolest things a photographer can do, because each shot is unique. The slightest movement of the CD creates a completely different composition. This image made me think of a bunch of jellyfish rising.

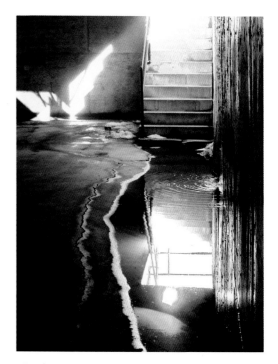

Darrin Hagen
Underground Lake
Edmonton, Alberta, Canada

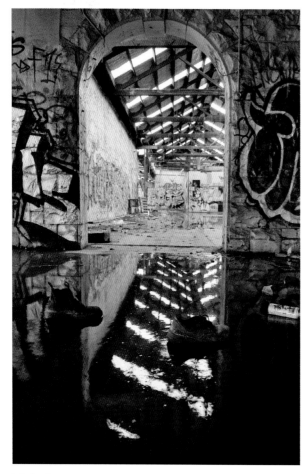

Daisy Rosengrave
Walking on Water
Melbourne, Australia

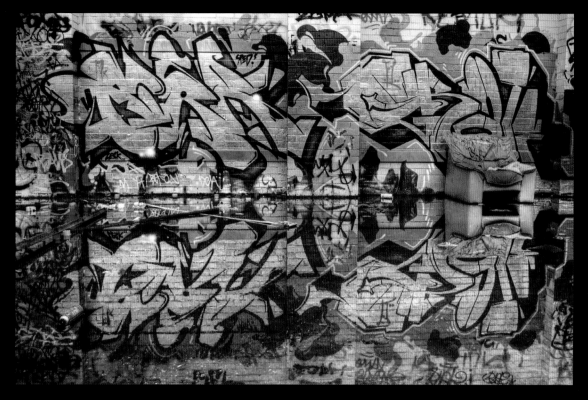

Daisy Rosengrave
Purple Reflections
Melbourne, Australia
Reflections challenge what we think is real and what is actually real.

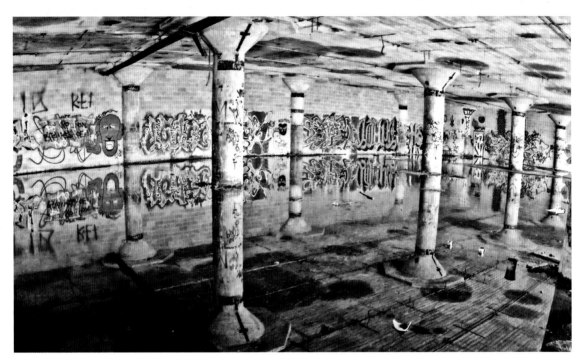

William D. Clark, MD
A Century of Reflections
Abandoned Packard Automotive Factory, Detroit, Michigan
This is a photo I took on the second floor of the crumbling seven-story
factory. Water had trickled all the way down to create some beauti-
ful reflections. One month after I shot the photo, this section of the
building collapsed. Most of the area shown here was buried under five
floors of concrete and steel.

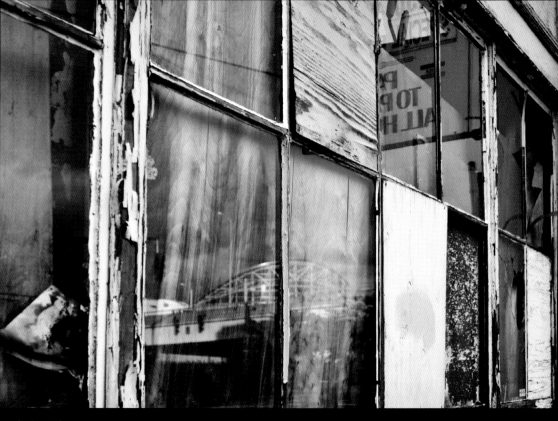

Jodi Linn Coleman
Dilapidated Convention
Portland, Oregon

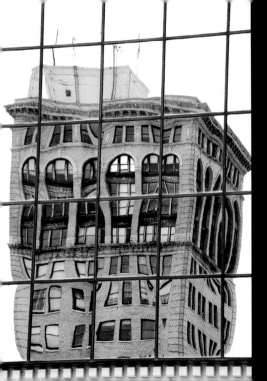
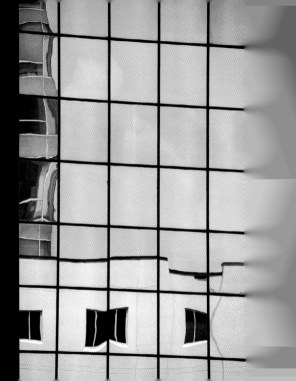

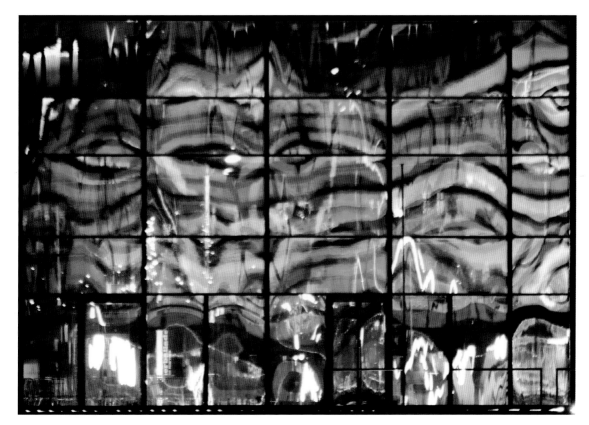

Günter Jörgenshaus
Abstract Faces
Copenhagen, Denmark

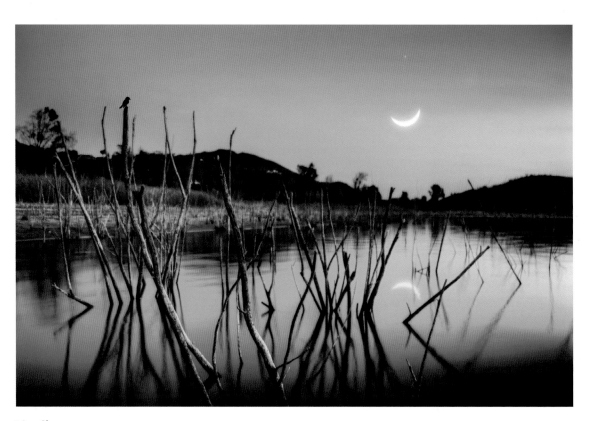

Lee Sie
Blue Lake
Lake Hodges, San Diego, California

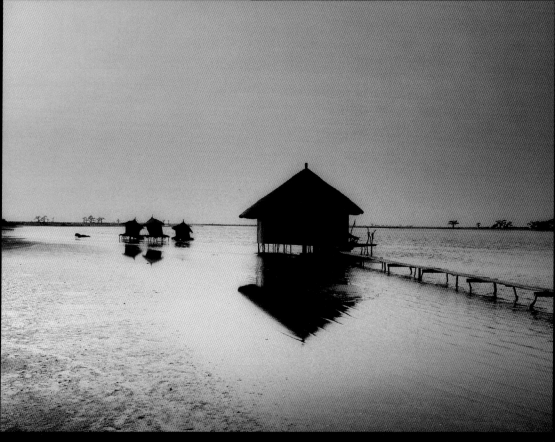

Camille Coignard
D'Or et d'Ambre
Palmarin, Senegal

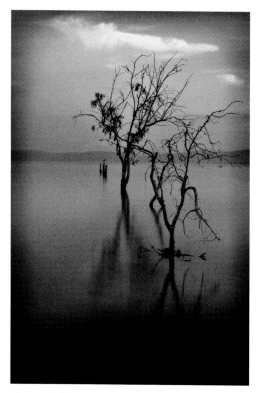

Leonardo Diaz
Lake Guardians
Lake Chapala, Jalisco, Mexico

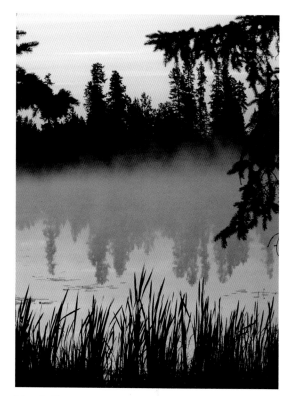

Darrin Hagen
Pink Morning Layers
Twin Lakes, Rocky Mountain House,
Alberta, Canada
Reflections make the familiar magical.

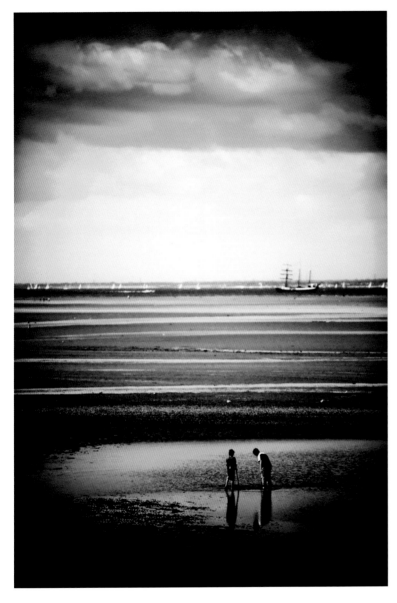

Andy Teo
The Seven Seas of Ryde
Isle of Wight, England

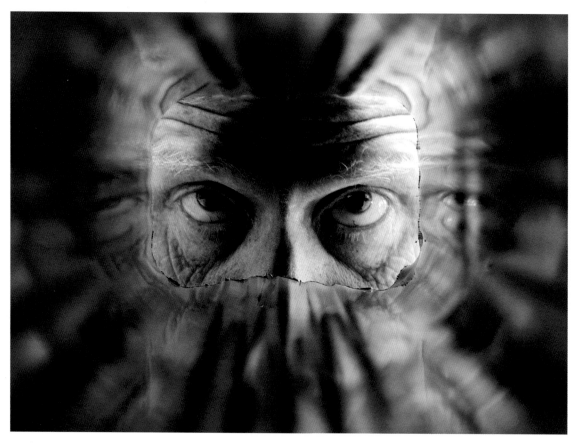

Richard H. Hebenstreit, Jr.
The Gutter Self-Portrait
Shawnee, Kansas

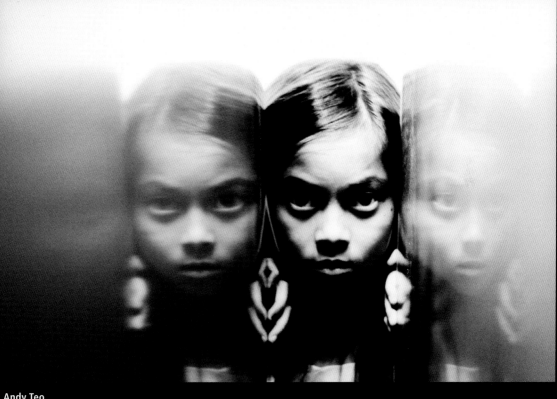

Andy Teo
Waiting to Pounce
Hampshire, England

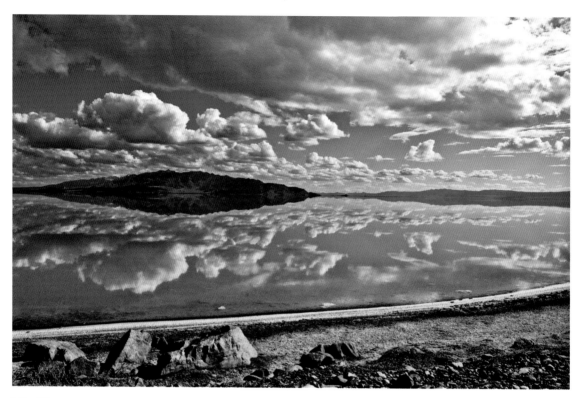

Brad Creze
Detonation
Stansbury Island, Great Salt Lake, Utah

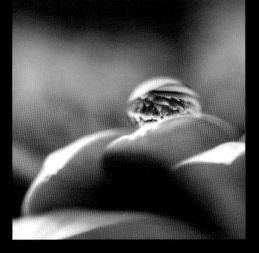

Norbert Schluess
Blossom Reflection
Schermbeck, Germany

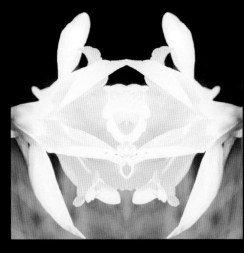

Ruth Hallam
Yellow Flower Reflection
Dorset, England

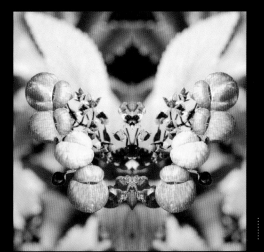

Ruth Hallam
Orange Flower Reflection
Victoria, Vancouver Island, Canada

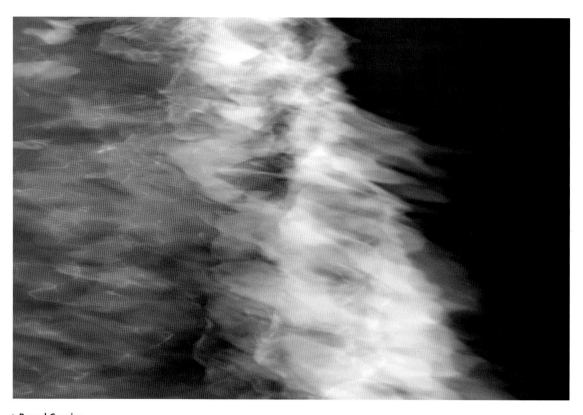

Pascal Cornier
ALN 9-41
Alonnisos, Thessalia, Greece

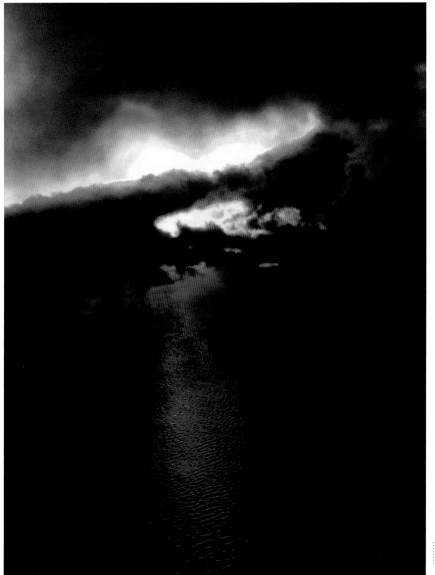

Brian Clancy McGuffog
Parallel to the Sky
Fishers, Indiana

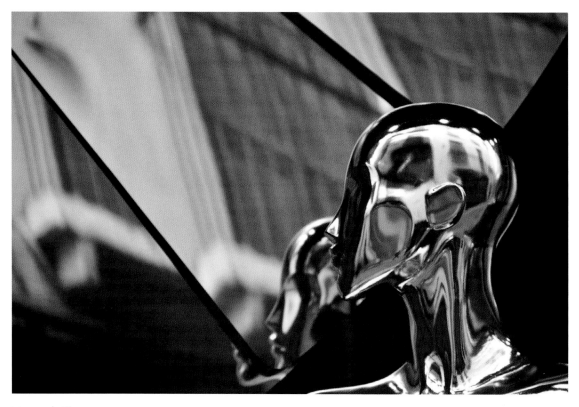

Leonardo Diaz
Futuristic Reflections
Seville, Spain

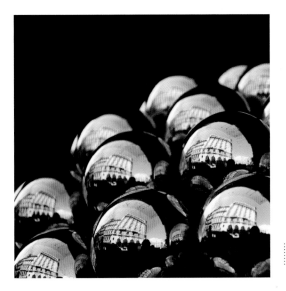

Howell Rhys Edwards
Roger de Llúria
Barcelona, Spain

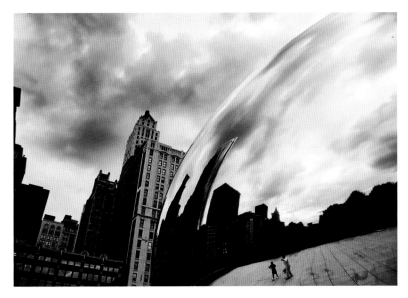

Brian Clancy McGuffog
The Lone Figures
Chicago, Illinois

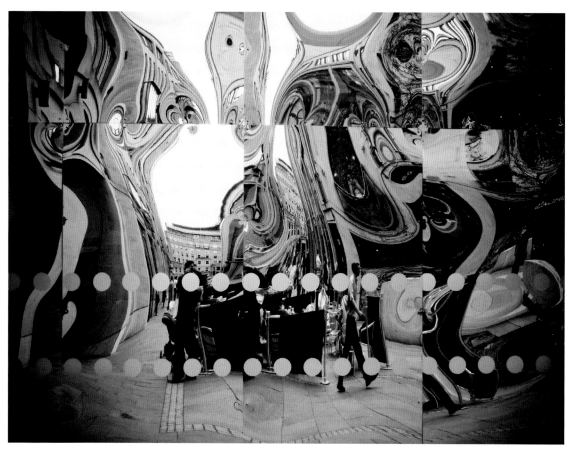

Rune Veslegard
Bitmap
Edinburgh, Scotland
Reflections create alternative realities. They combine
fractions of life in new and unexpected ways.

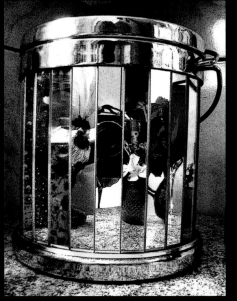

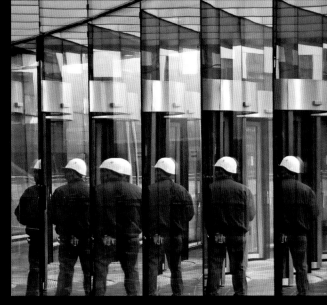

Osvaldo Eaf
Fractions
Goiânia, Brazil

Loïc Kervagoret
Ubiquity
La Défense, Paris, France

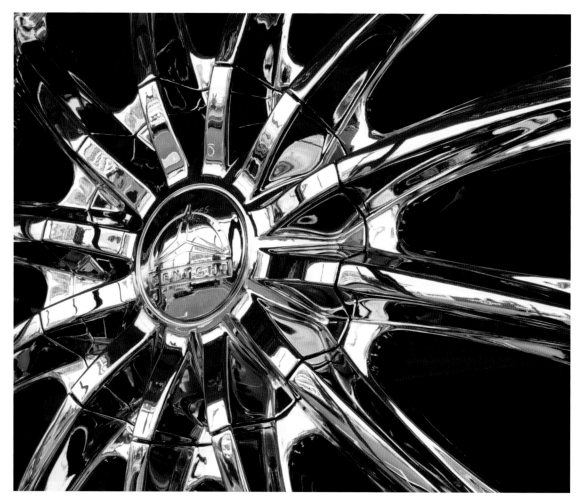

Jodi Linn Coleman
radial
Portland, Oregon

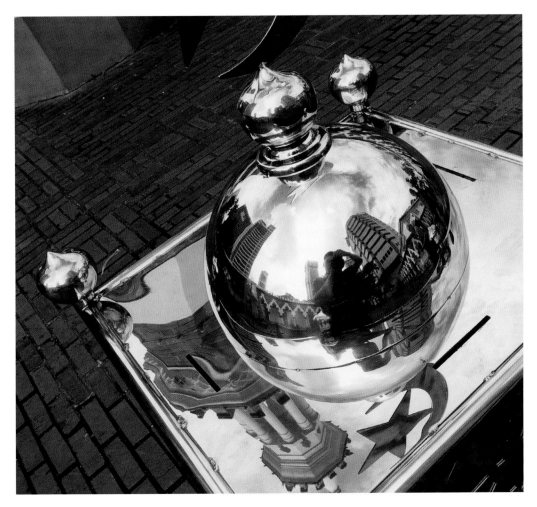

Edwin Louis G. Arcilla
Reflecting at Masjid Jamek
Kuala Lumpur, Malaysia

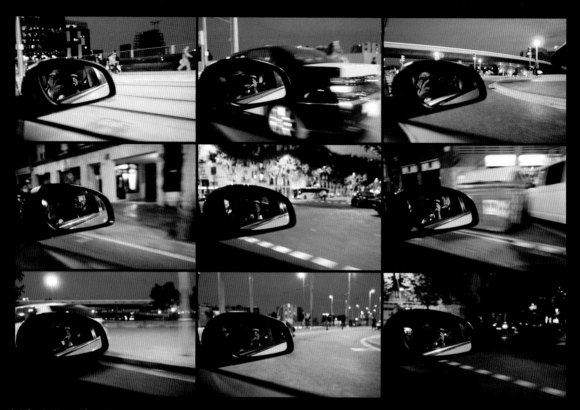

John F. Wenceslao, MD
Drive-by Shooting, Avinguda Diagonal
Barcelona, Spain
Reflections have surely titillated the human vision and psyche
since prehistoric times. The human mind is captive to their spell.
Photography equips us with the tool to freeze these elusive illusions
and share them with others.

Günter Jörgenshaus
Elbphilharmonie Hamburg—
Reflected Blue Sky
Hamburg, Germany

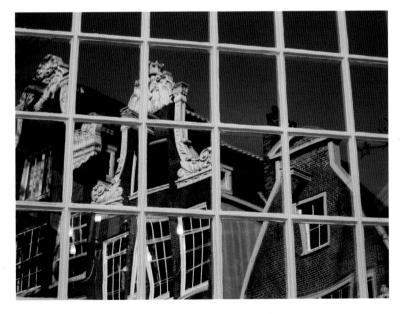

B. Kim Barnes
Beginhof Reflections
Amsterdam, Netherlands

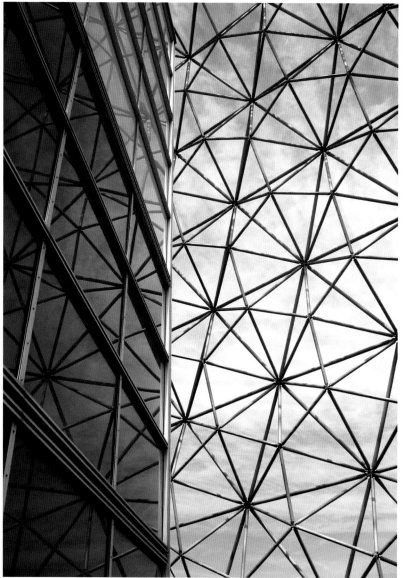

David McConville
Biosphere
Montreal, Quebec, Canada

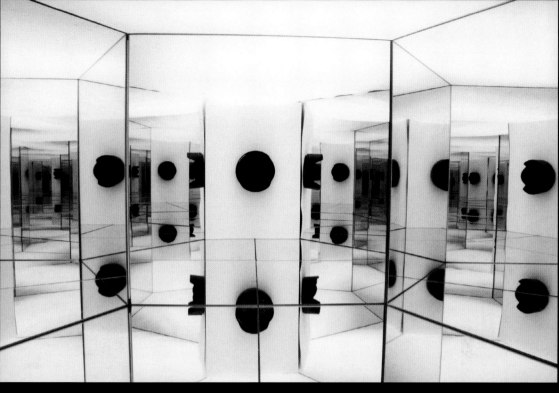

Karl Bernéli
Inside a Hexagon
Veberöd, Sweden

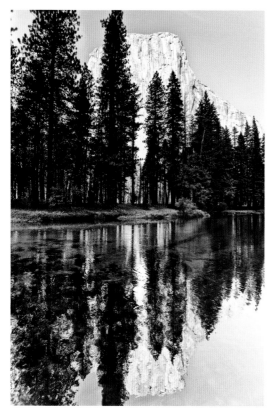

Dave Hodges
El Capitan and the Merced River
Yosemite National Park, California

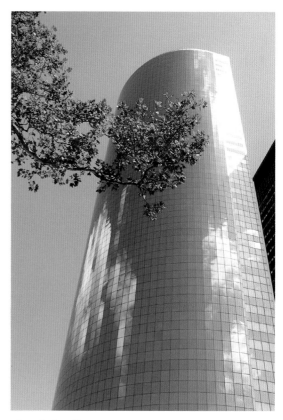

Luca Strippoli
Artificial Sky
New York, New York

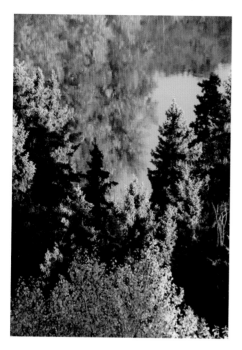

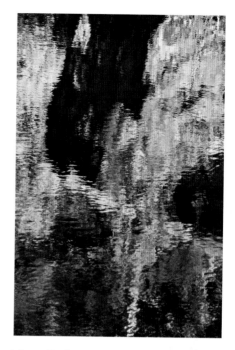

Darrin Hagen
River Mirror
Edmonton, Alberta, Canada

Janne Hytti
Anni Savolainen
Aquarelle Painting
Tuusniemi, Finland

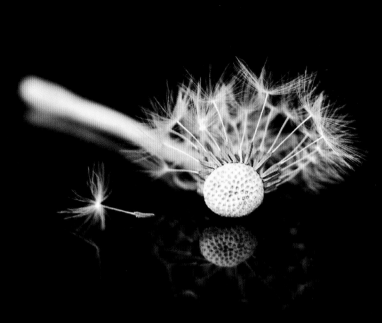

Michelle McMahon
Dandelion Reflection
Radcliffe, Manchester, England
I notice reflections everywhere, on buildings and in puddles.
Reflections often produce unusual angles, which lead to interesting
visual compositions, so I love to focus on them in my photographs.

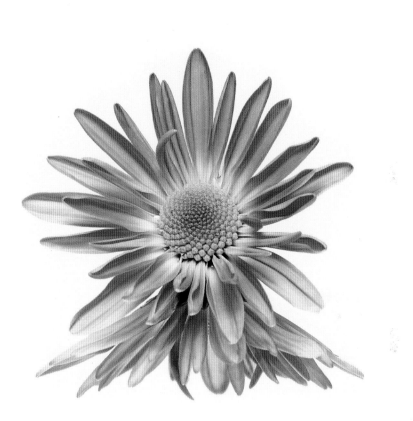

Jan Crites
Pink Flower Times Two
Geneva, Illinois

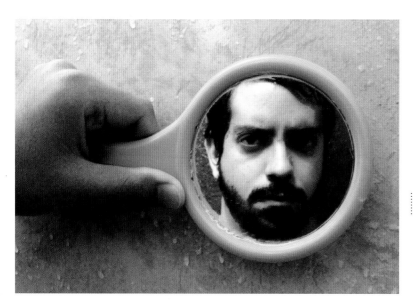

Osvaldo Eaf
Self-Portraited
Goiânia, Brazil
Reflections are about seeing the
world from a new perspective, one
that allows you to discover new
aspects of things and people that you
might have ignored before.

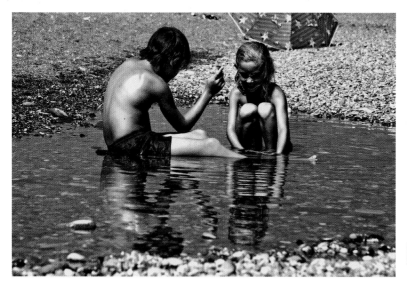

Giovanna Del Bufalo
Giochi in Acqua
Calatabiano, Italy

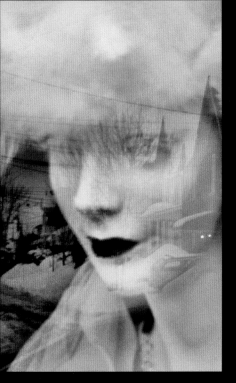

Lee-Anne McMullan
Winter Woman
Ottawa, Canada
When shooting reflections, I look for images that
confure the eye and make the viewer wonder what's
really being reflected.

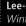

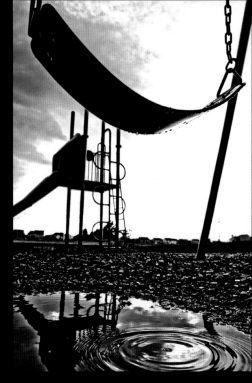

Brian Clancy McGuffog
A Ripple in Time
Fishers, Indiana

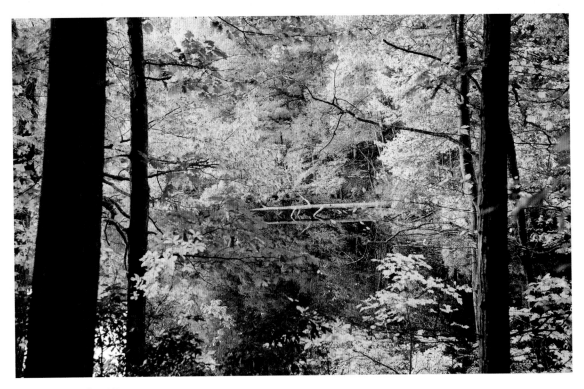

John F. Wenceslao, MD
Griswold Pond
Chester, Connecticut

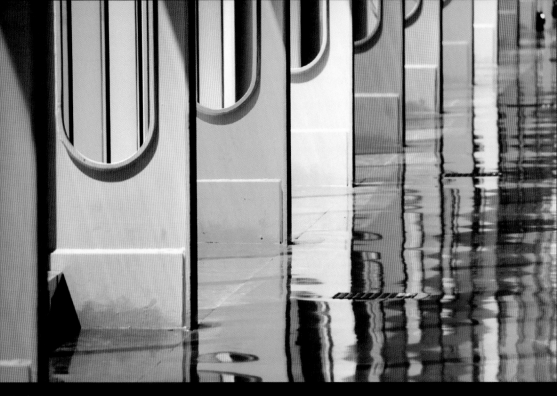

Martin Provost
Pluralisme
Montréal, Quebec, Canada

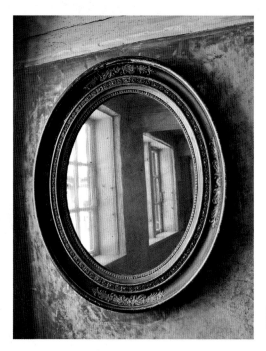

Monica Oldenburg
Ghostly Mirror
Denmark

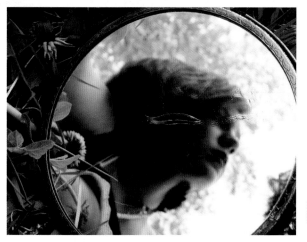

Lindsay A. Taylor
A Journey across the Looking Glass
Midland, North Carolina

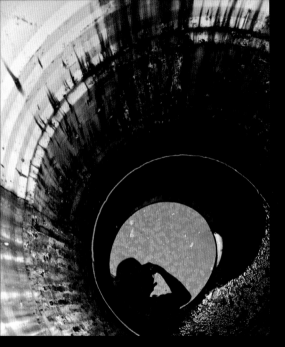

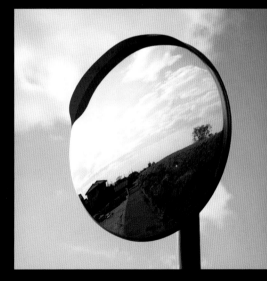

Edwin Louis G. Arcilla
A Peek Inside
Gapan City, Nueva Ecija,

Jamiyansuren Jambaldorj
What You See in the Mirror . . .
Tokushima City, Kitajima District, Japan

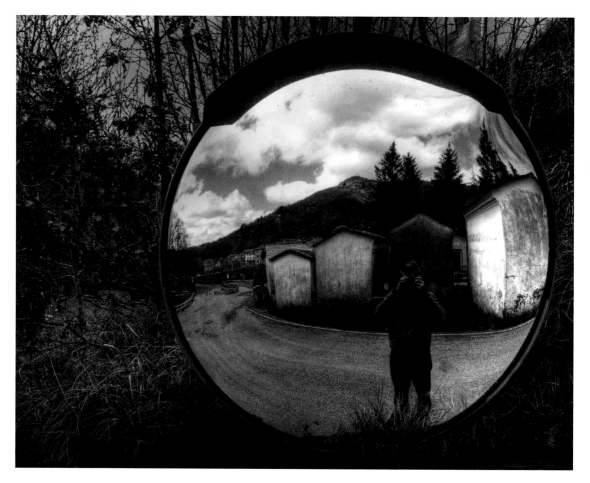

Paolo Tomati
Fisherman-Eye
Montebruno, Italy

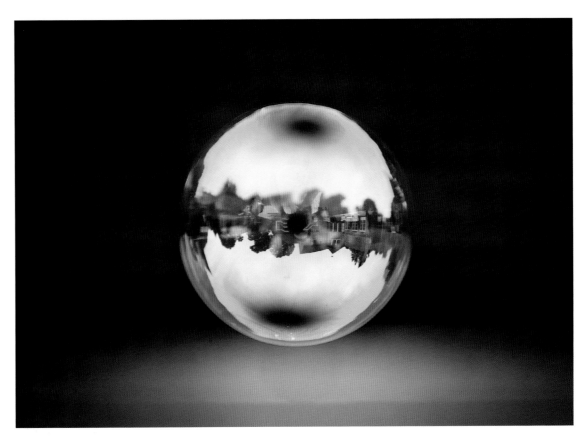

Nicholas Breslow
Orbital
East Hampton, Long Island, New York

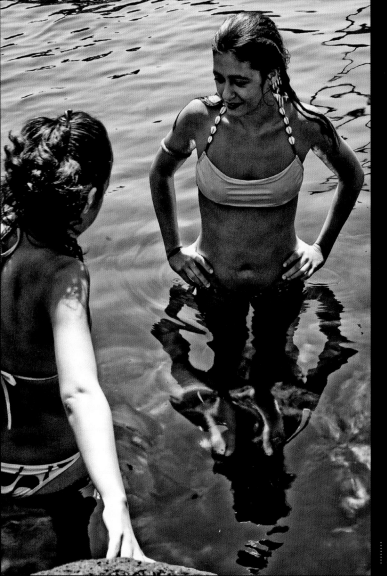

Giovanna Del Bufalo
Sorelle a Mare
Catania, Italy

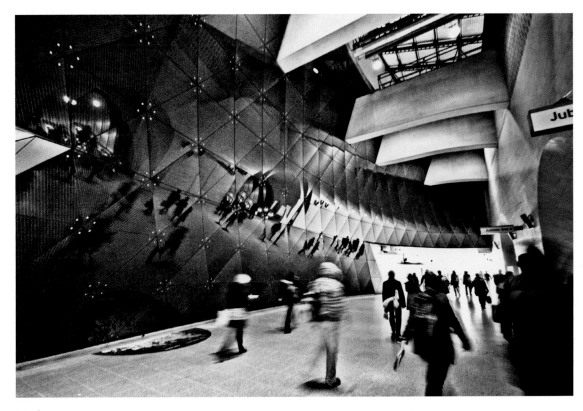

Andy Teo
Departure
London, England

Jan Crites
Lily Drops
St. Louis, Missouri

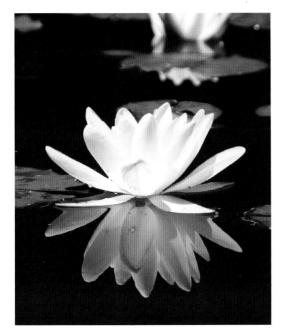

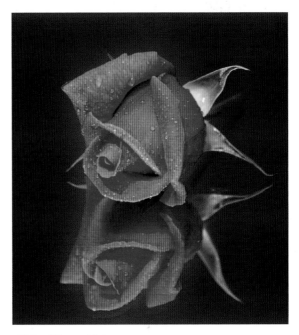

Milena Oehy
Water Lily
Frauenfeld, Switzerland

Richard Howard Johns
A Rose for My Friends
Plymouth, Devon, England

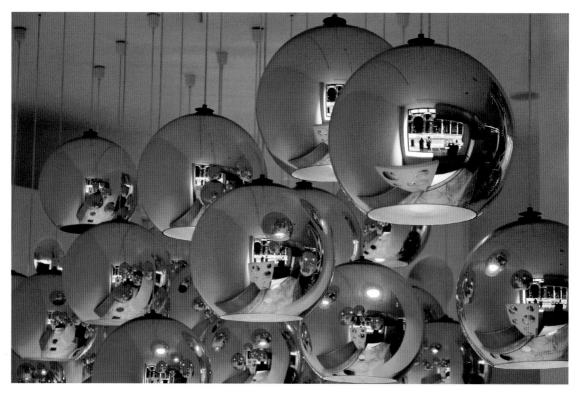

Roberto Faleni
Luci a Milano
Milan, Italy

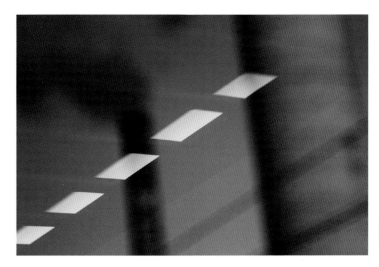

Taj Dickinson
Stack Abstract
Southbound Train out of New York City

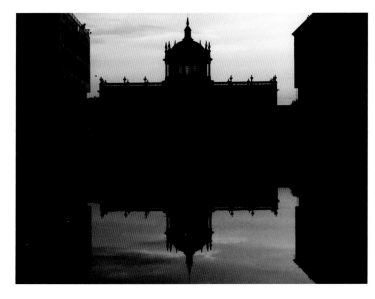

Leonardo Diaz
Cabañas Cultural Institute
Guadalajara, Mexico

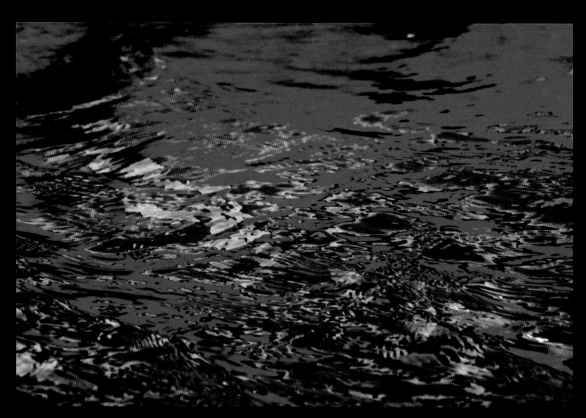

Peggy Reimchen
A Touch of Blue in a Sea of Red
Bluebird Estates, County of Wetaskiwin, Alberta, Canada

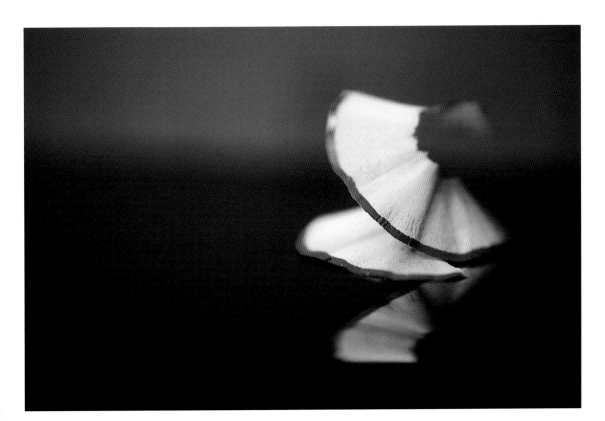

Michelle McMahon
Pencil Shaving
Radcliffe, Manchester, England

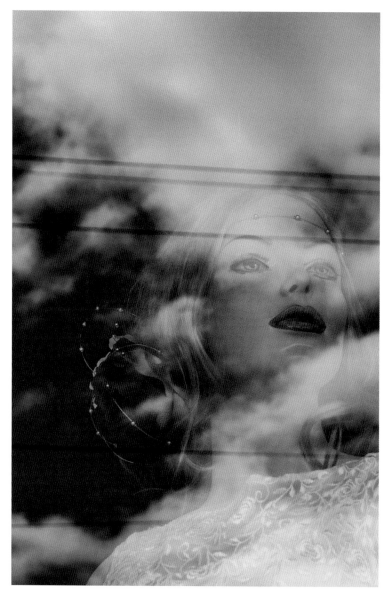

Lee-Anne McMullan
Last Dance
Ottawa, Canada

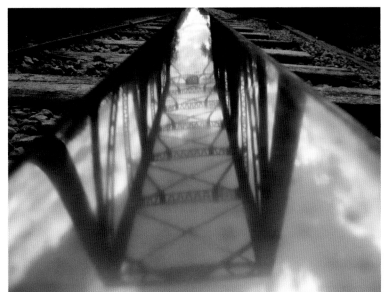

Jeremy Walter
Skyway
Independence, Missouri

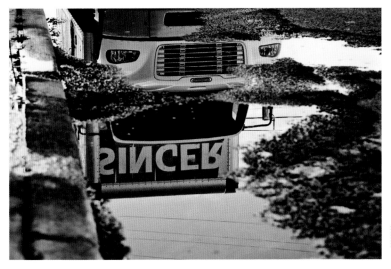

Taj Dickinson
Singer
Seaside Heights, New Jersey

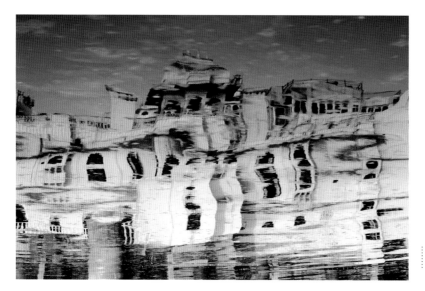

Watana Suthisomboon
Udaipur, Rajasthan, India
Rajasthan, India

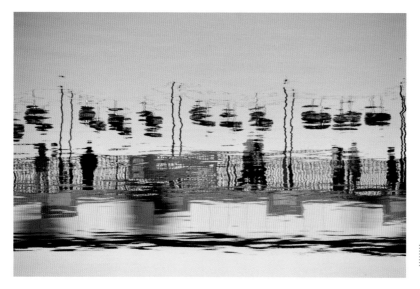

Richard H. Hebenstreit, Jr.
Brush Creek Reflections
Kansas City, Missouri

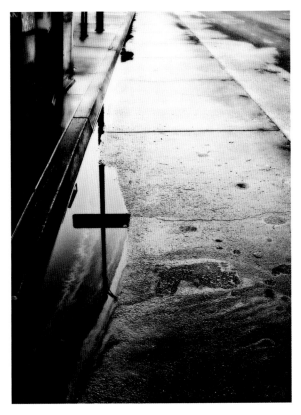

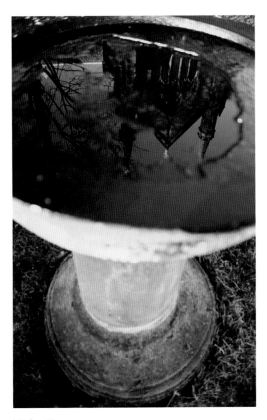

Shando Darby
Wet Street in Early Morning
San Francisco, California

Brian Mason
Saint Patrick's Reflection
Armagh, Ireland
I prefer photographs with strong colors, patterns, and high contrast. By using reflections, I'm able to add these features, along with mirror images and distortions, to my work.

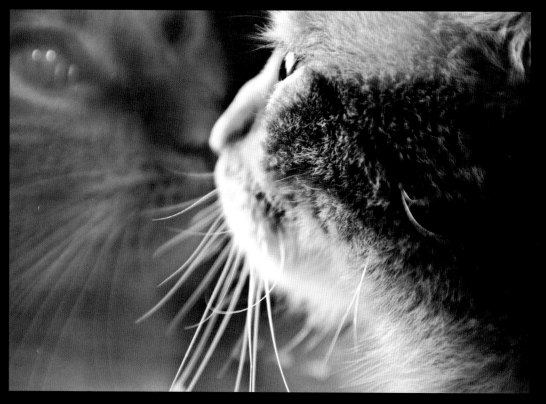

Susan Leurs
I Spy with My Eye
Stein, Netherlands

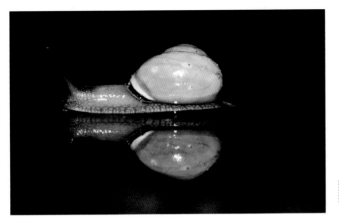

Jutta Voetmann
Snail in the Rain
Kalkar-Wissel, Germany

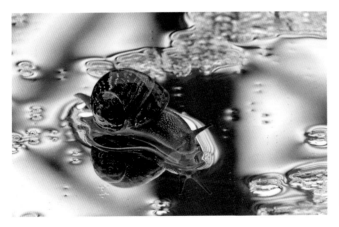

Richard Howard Johns
Sliding Snail
Plymouth, Devon, England

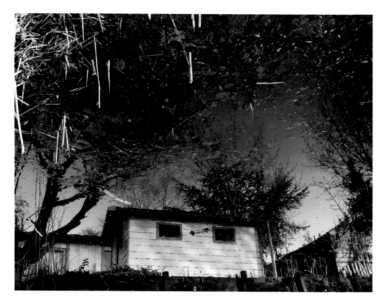

AmsterSam
Back to Nature
Amsterdam, Netherlands

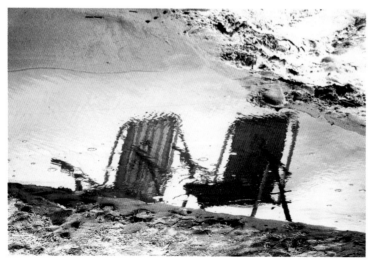

Peggy Reimchen
Life in the Slow Lane
Praia de Jureré, Santa Catarina, Brazil

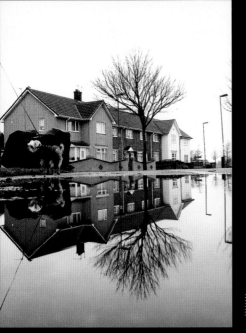

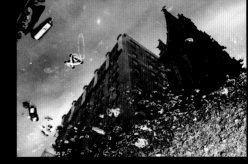

Gerard Garcia
Urban Detritus
New York, New York

Rosalind Young
Timmy's Travels
Hartlepool, England

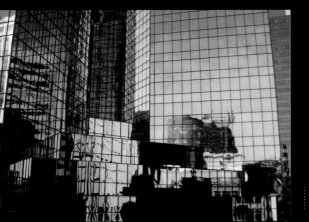

Darrin Hagen
The City Behind You
Edmonton, Alberta, Canada

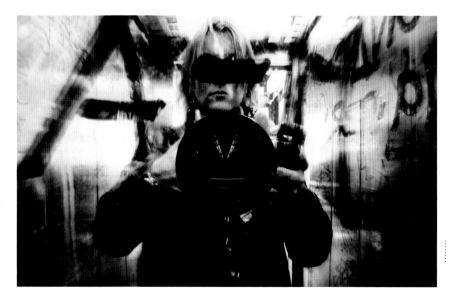

Floortje van der Vlist
The Elevator
Zaandam Central Station,
Netherlands

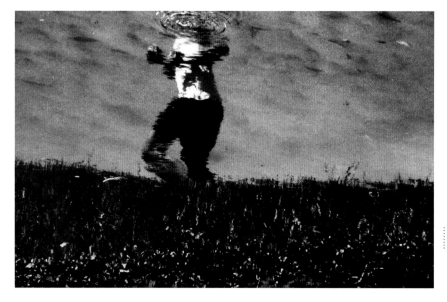

Peggy Reimchen
*Things Are Not Always
What They Seem*
São Lourenço Park, Curitiba,
Brazil

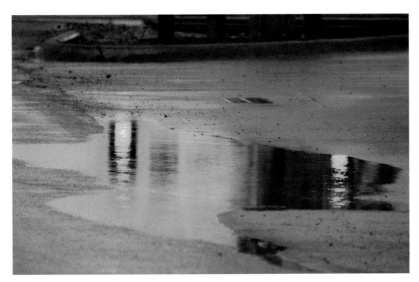

Rhonda Gibson
Think About It Thursday/Go
Stilwell, Oklahoma

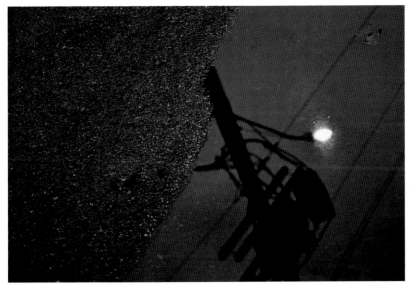

Jodi Linn Coleman
Nightlight
Portland, Oregon

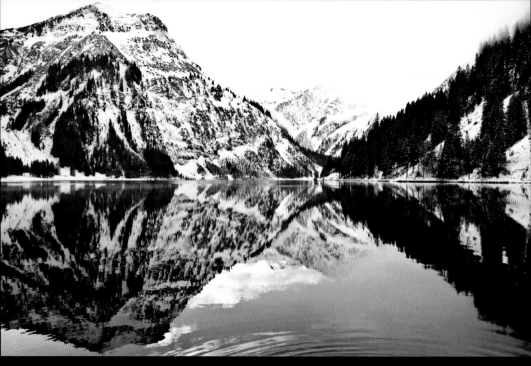

Susan Leurs
Breathtaking Twins
Tannheim, Tirol, Austria

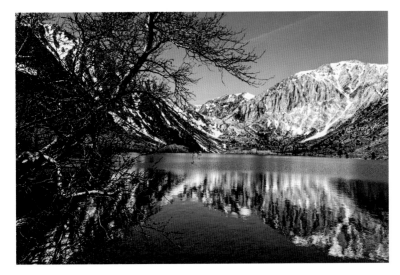

Dave Hodges
Convict Lake
Convict Lake, Mammoth Lakes, California

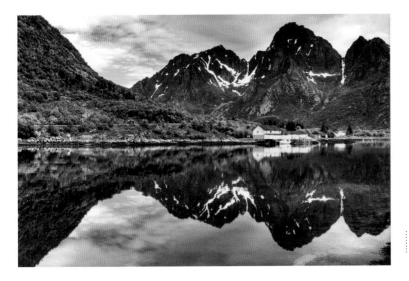

Norbert Schluess
The Beauty of Nature: Lofoten Islands
Lofoten Islands, Norway

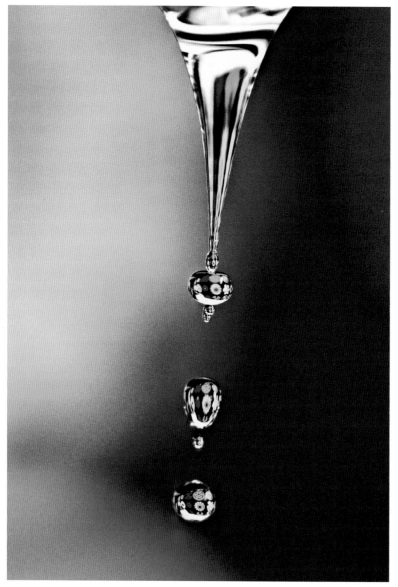

Robert Zaffaroni
Reflections in Multicolored Drops 1
Nerviano, Italy

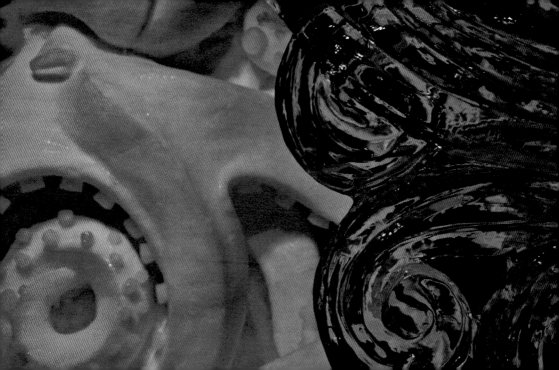

Watana Suthisomb
Prague, Czech Rep

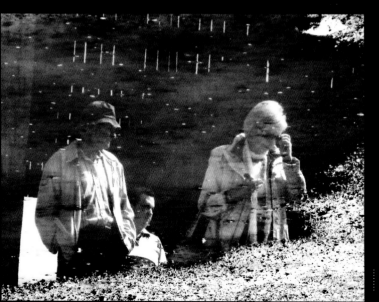

Peggy Reimchen
The Family
Kumrovec, Croatia

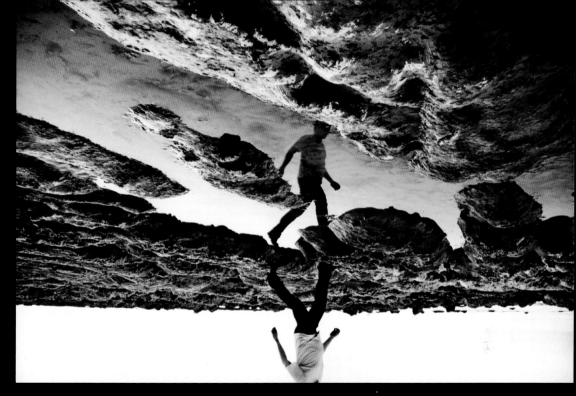

Ida Pap
Gliding Through
Eastbourne, East Sussex, England

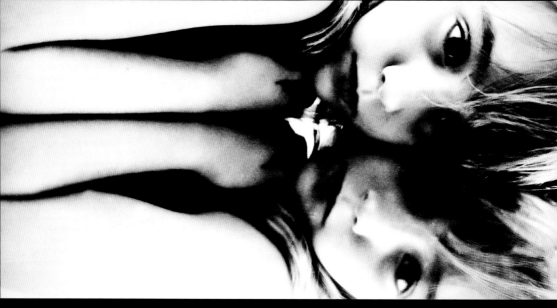

Floortje van der Vlist
Lotte
Zaandam, Netherlands

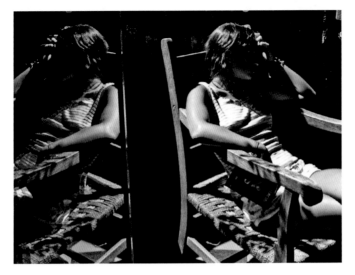

Giovanna Del Bufalo
Quasi Due
Catania, Italy

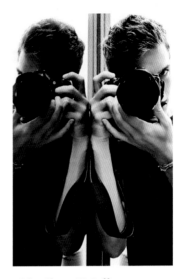

Brian Clancy McGuffog
Mine
Fishers, Indiana

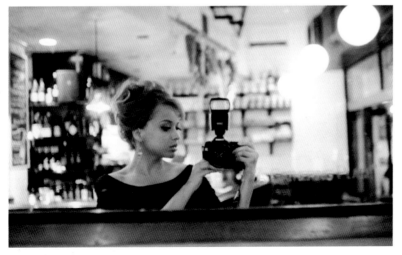

Christine Jean Chambers
Christine Jean
Upper West Side, New York, New York

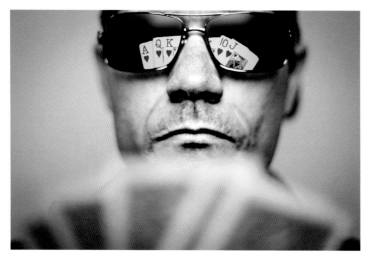

Eric A. Nelson
Poker Face
Irvine, California
For me, the challenge of photographing reflections lies in finding the right focal point. Using the reflection as the primary point of interest in a photo can make an image more evocative.

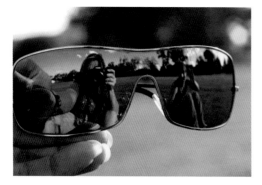

Nicole Cordeiro
Beautiful Sunny Saturdays
Dallas, Texas

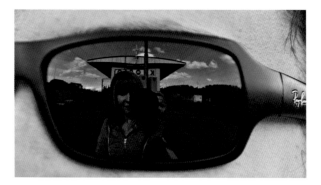

Janne Hytti
Anni Savolainen
Waiting for a Train
Kuopio, Finland

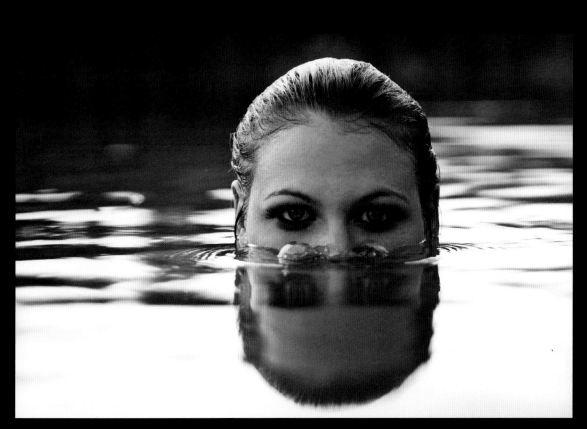

Jutta Voetmann
Double Face
Kalkar-Wissel, Germany

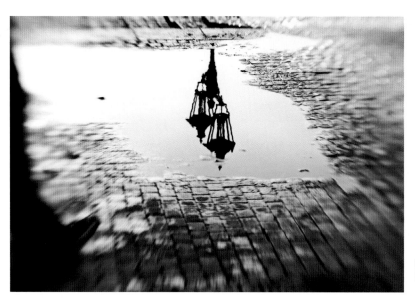

Ida Pap
I Believe
Prague, Czech Republic

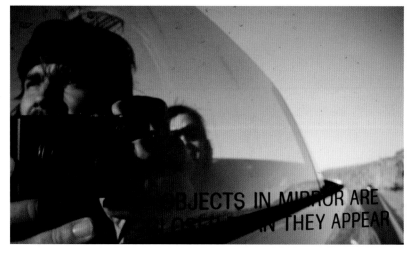

Rune Veslegard
*Objects in Mirror Are Closer
Than They Appear*
Las Vegas, Nevada

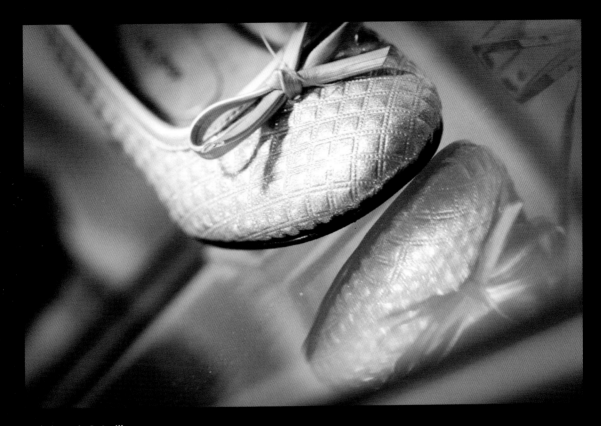

Edwin Louis G. Arcilla
Toe to Toe
Pasig City, Philippines

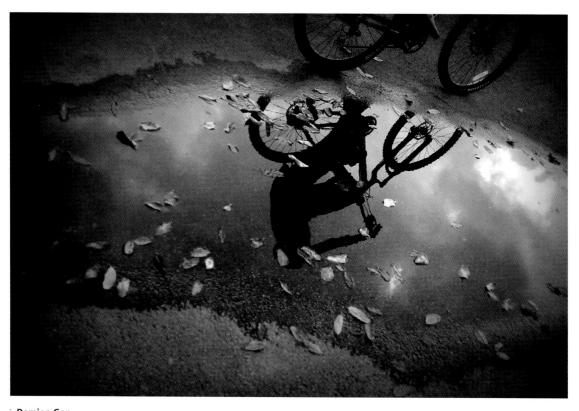

Damien Gan
Before the Rain
Marina Boulevard, Singapore

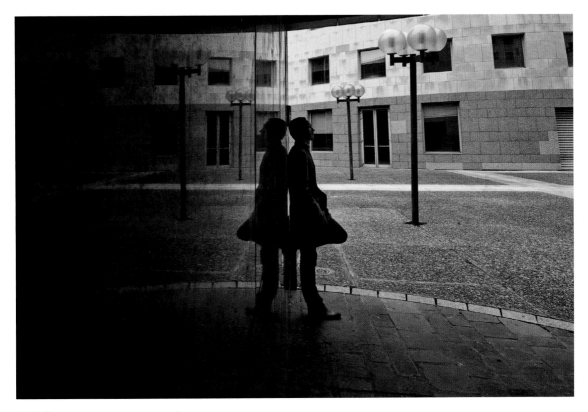

Loïc Kervagoret
Two-Face
La Défense, Paris, France

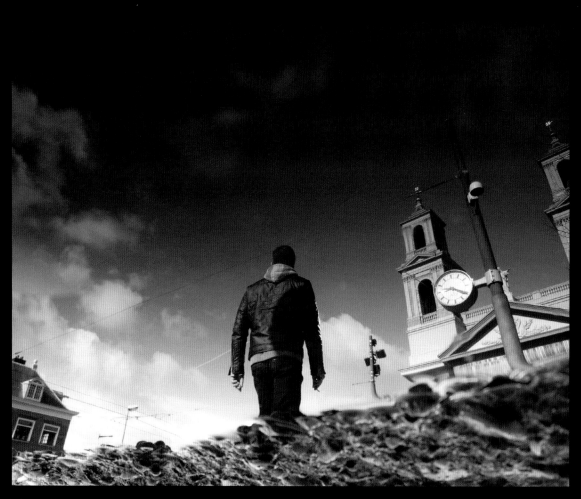

AmsterSam
Looking for the Lord
Amsterdam, Netherlands

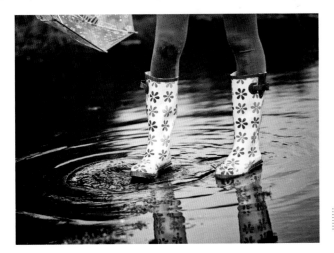

Andy Teo
It's Raining Again
Hampshire, England

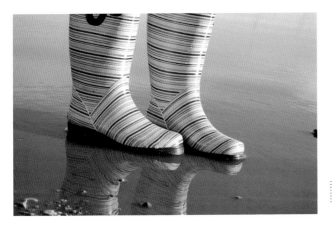

Rhonda Gibson
Reflections in the Sun
Stilwell, Oklahoma

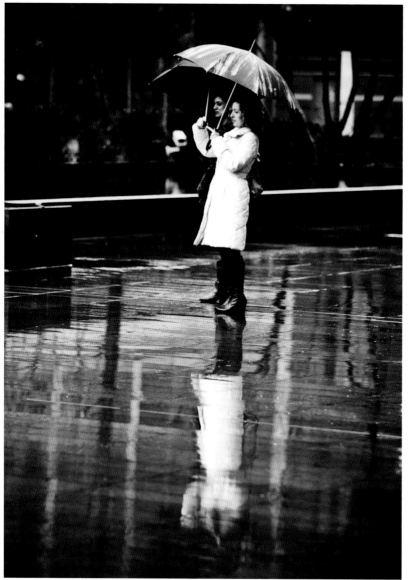

Andy Teo
The Weather Girls
London, England

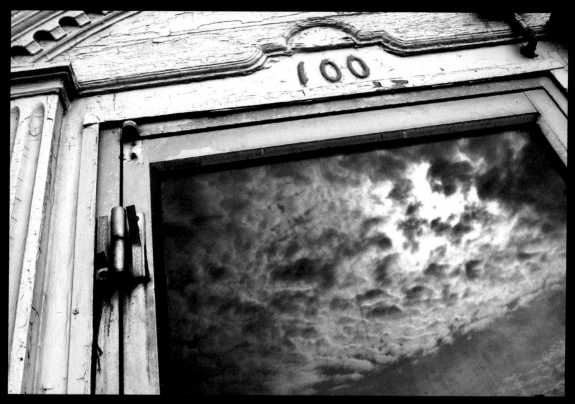

Taj Dickinson
Reflections of Weather in a Weathered Doorway
Seaside Heights, New Jersey

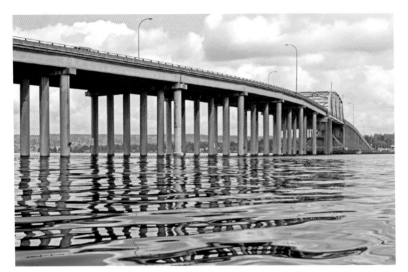

Alex Russell
Waves and Pillars
Seattle, Washington

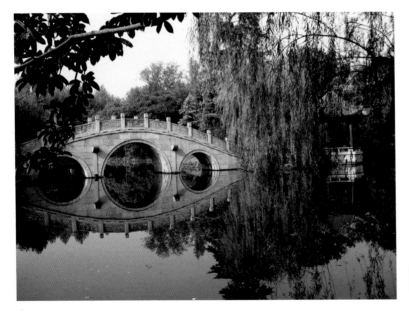

Milena Oehy
West Lake Hangzhou I
Hangzhou, China

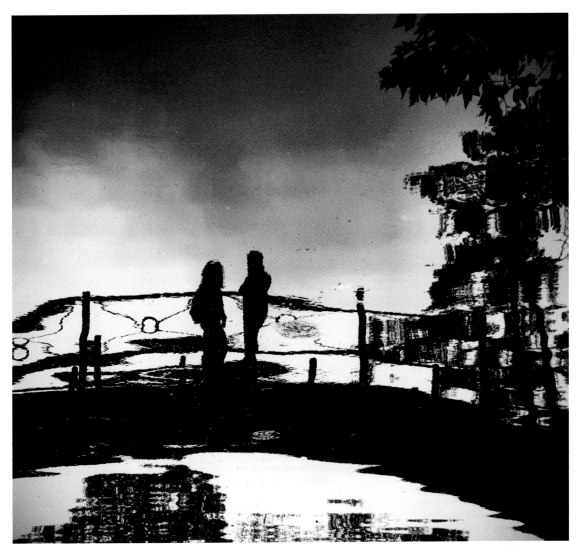

Ida Pap
First and Last Day
Oxford, England

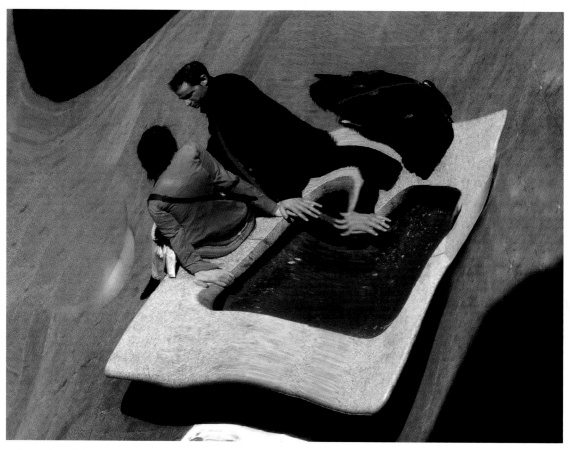

Giovanni Paolini
Amore Riflesso
Corso Vittorio Emanuele, Milan, Italy
I was wandering around with my camera when I saw this reflection of two lovers on the steel ceiling of a shop. I thought they were a beautiful pair.

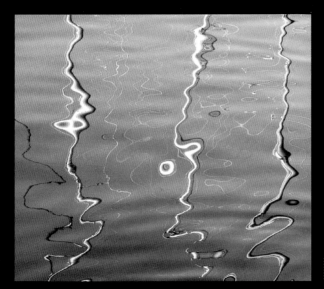

Steven K. Feather
Masts
Bowness, Lake Windermere, Cumbria, England

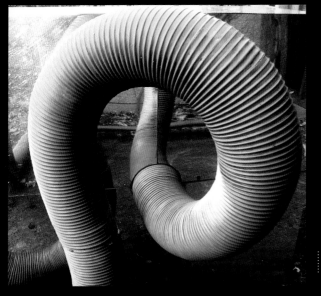

Eduardo da Costa
Controlled Blossoming
Liège, Belgium

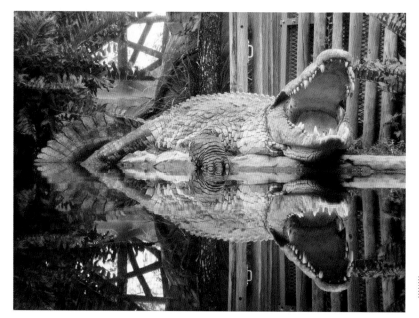

Andy Teo
Killer Reflections
Tampa Bay, Florida

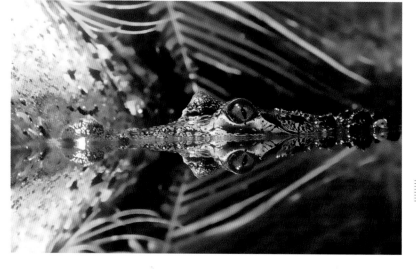

Mark Prime
It's All in the Eye
Tropical World, Roundhay Park,
Leeds, England
Photos of reflections offer new per-
spectives on the everyday world.

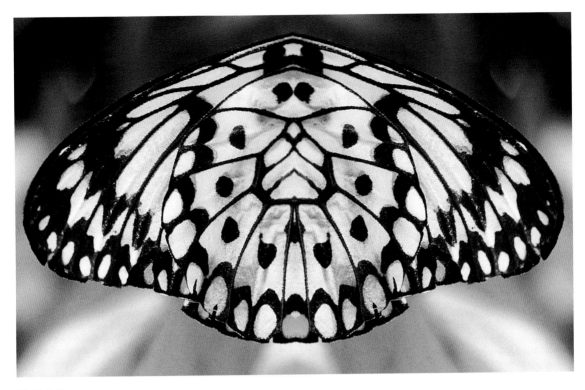

Ruth Hallam
Butterfly Wing Reflection
Victoria, Vancouver Island, Canada

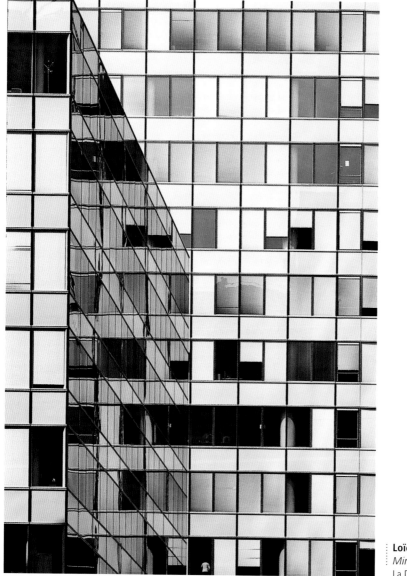

Loïc Kervagoret
Mind Maze
La Défense, Paris, France

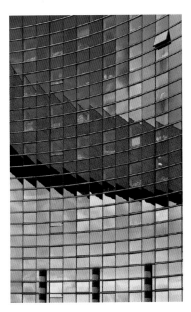 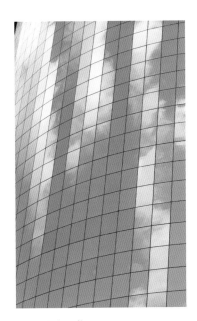

Loïc Kervagoret
Pixel Line
La Défense, Paris, France

Gerard Garcia
Reflecting Grace
New York, New York

Luca Strippoli
City Clouds
New York, New York

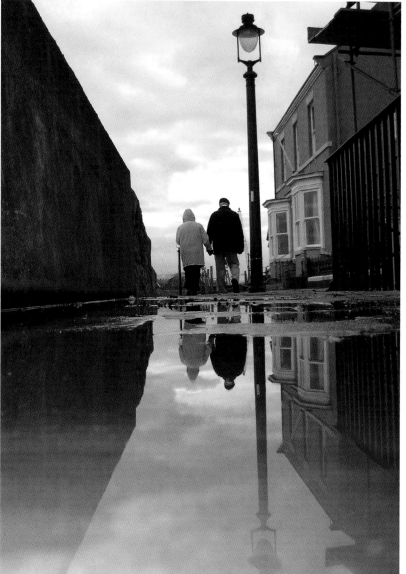

Rosalind Young
Walk Down Memory Lane
Headland, Hartlepool, England

Index of Contributing Artists

Also available in the F◯CUS series:

ISBN: 978-1-60059-563-9

ISBN: 978-1-60059-680-3

ISBN: 978-1-60059-792-3

ISBN: 978-1-60059-711-4

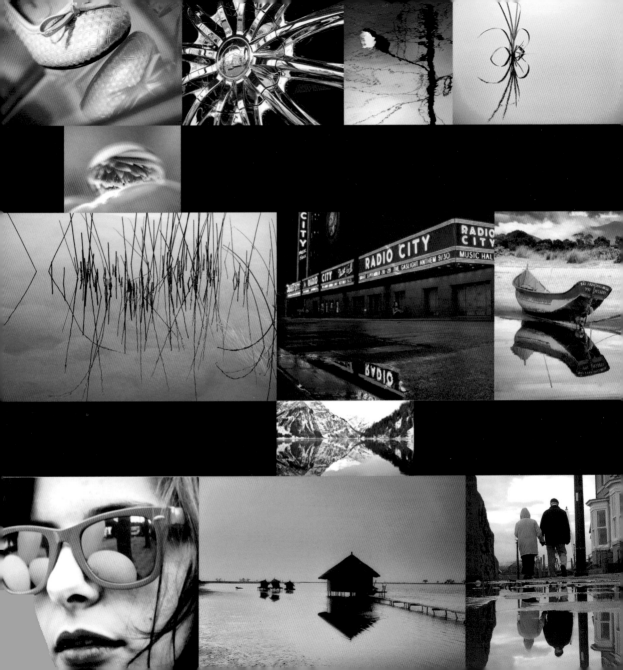